IMAGES
of America

GEORGIA'S CIVILIAN
CONSERVATION CORPS

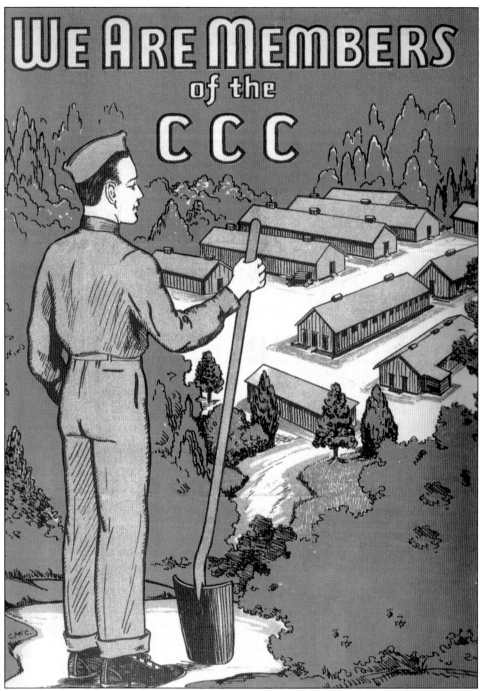

This is sheet music for "We Are Members of the CCC." Three nationwide radio networks broadcasted this song, dedicated to Franklin D. Roosevelt. (Courtesy of the National Park Service.)

ON THE COVER: A portion of a May 12, 1939, photograph of Camp Chipley's CCC company is featured here. The entire photograph can be seen on page 54. (Courtesy of the Georgia Department of Natural Resources.)

IMAGES
of America

GEORGIA'S CIVILIAN CONSERVATION CORPS

Connie M. Huddleston

Copyright © 2009 by Connie M. Huddleston
ISBN 978-0-7385-6837-9

Published by Arcadia Publishing
Charleston, South Carolina

Printed in the United States of America

Library of Congress Control Number: 2008937408

For all general information contact Arcadia Publishing at:
Telephone 843-853-2070
Fax 843-853-0044
E-mail sales@arcadiapublishing.com
For customer service and orders:
Toll-Free 1-888-313-2665

Visit us on the Internet at www.arcadiapublishing.com

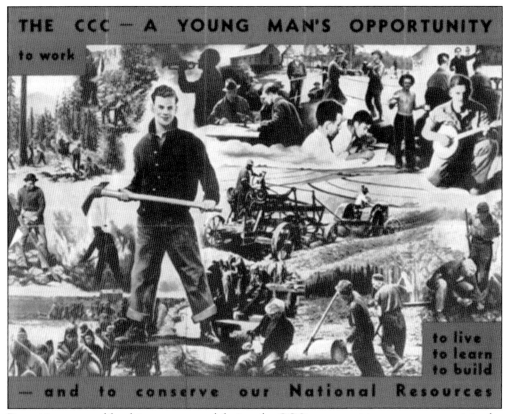

Recruiting posters like this one appeared during the CCC years, enticing young men to join the corps. (Courtesy of National Archives.)

Contents

Acknowledgments		6
Introduction		7
1.	Day by Day in the CCC	11
2.	Roosevelt's Tree Army	21
3.	Building Georgia's State Parks	27
4.	The Work of Veterans	67
5.	Chehaw and Santa Domingo	83
6.	Images from Georgia's Other Camps	91
7.	After the Work Day Ended	107
8.	Georgia's CCC Legacy	121
List of CCC Camps		126
Bibliography		127

ACKNOWLEDGMENTS

In each of our lives, we have witnessed, heard about, or read stories that we could not wait to tell someone else. When I began researching the Civilian Conservation Corps, the personal stories of the men themselves—repeated at annual reunions, told on oral history tapes, and written in memoirs—made the history of the CCC one worth repeating. Finding the boxes and files of unpublished and rarely seen photographs of these men on the shelves of the National Archives in College Park, Maryland, only increased my desire to share their story. Almost none of the photographs were labeled with names of the subjects, yet these often grainy images revealed a little more of Georgia's New Deal history. This book is dedicated to those boys who became men and the "veterans" of the CCC.

This book would not have been possible without the cooperation of the staff of the National Archives at College Park and my friends at the Georgia Department of Natural Resources, State Parks and Historic Sites. In particular, I give thanks to Dr. Debbie Wallsmith, James Hamilton, Linda Bitley, Sim Davidson, Don McGhee, and Suzanne Passmore.

I sincerely thank my dear friends who served as editors, Sherron Lawson and Gwen Koehler, daughter of a CCC man. With great love, I want to express my gratitude to my husband, Charlie, who edited this book and supported my efforts to see it in print. Also, my thanks goes to Katie Stephens at Arcadia Publishing for her patience and guidance. To my son, Adrian, you would have liked this story.

INTRODUCTION

The year was 1933; one in four young men between the ages of 15 and 24 found himself unemployed as a result of the Great Depression. Then the United States swore in a new and vital president—Franklin Delano Roosevelt (FDR)—who promised a "New Deal" for every American.

The Great Depression began in 1929 on Black Tuesday, October 29, with the great stock market crash. Its devastating effects broadsided industrialized countries and those importing raw materials. International trade plummeted; construction halted. As crop prices fell by 40 to 60 percent, farming and rural areas suffered. Mining and logging industries collapsed. Incredible numbers of men and women could not find work—some 12 to 15 million. In cities, bread and soup lines formed.

In the United States, almost two million men and women took to the road, traveling in rail cars or on foot from city to city and town to town looking for food, for work, and for security. A quarter-million of these lost souls were the teenage tramps of America. These young people wandered, looking for a future. Their rescue became critical to the survival and success of the United States.

In addition to this crisis of unemployment, the American landscape stood scarred from three generations of poor farming and logging practices. Virgin timber was reduced to a mere 100 million acres, down from 800 million. Soil erosion devastated once profitable farmland as three billion tons of rich topsoil washed away each year. Wind accounted for almost as much lost soil, especially in the Great Plains, where deserts of dust formed where rich grasslands once existed.

Hatched during the early days of his administration, President Roosevelt's idea to employ America's young unmarried men, ages 18 to 25, in conservation programs across the United States became one of the most successful government programs ever created. On March 9, 1933, only five days after his inauguration, FDR outlined the program to members of his cabinet. Speaking to the secretaries of the Departments of Agriculture, the Interior, and War; the director of the budget; the army's judge advocate general; and the solicitor of the Department of the Interior, he sketched out his plan. Seeking immediate action, FDR asked Col. Kyle Rucker, the army's judge advocate general, and Edward Finney, the Department of the Interior solicitor, to prepare a draft bill by that evening. The men presented their plan to the president at 9:00 p.m.

The original draft proposed recruiting 500,000 young men a year to be employed in conservation and public work projects. The army would recruit the enrollees and organize the camps, while the Departments of Agriculture and Interior would create and run the work programs. FDR wanted 250,000 young men employed by early summer in the new Civilian Conservation Corps (CCC).

On March 15, 1933, in his third press conference, FDR discussed at length this need for work in America's forests, the number of men that could be employed, and the proposed wage of $1 per day. There was a strong reaction from organized labor, who had an aversion to the role the army would play in the program. Additionally, labor leaders argued that the creation of such a force "would place Government's endorsement upon poverty at a bare subsistence level."

Forestry officials and unions worried about the effects of placing $1-a-day men to work beside $3-a-day men. Francis Perkins, secretary of labor, emphasized that the administration saw this new program as a relief measure directed at one segment of the society—young, unmarried men who would be provided with food, shelter, and work clothing, along with medical and dental care. These young men would be volunteers, not drafted.

Roosevelt's message to Congress on March 21 read:

> I propose to create a Civilian Conservation Corps to be used in simple work, not interfering with normal employment, and confining itself to forestry, the prevention of soil erosion, flood control, and similar projects. More importantly, however, than the material gains, will be the moral and spiritual value of such work. The overwhelming majority of unemployed Americans, who are now walking the streets and receiving private or public relief would infinitely prefer to work. We can take a vast army of these unemployed out into healthful surroundings. We can eliminate to some extent at least the threat that enforced idleness brings to spiritual and moral stability. It is not a panacea for all the unemployment, but it is an essential step in this emergency. . . . I estimate that 250,000 men can be given temporary employment by early summer if you will give me the authority to proceed within the next two weeks.

After substantial debate in committee, the bill finally came before Congress. It simply authorized the president to create the CCC "under such rules and regulations as he may prescribe, and by utilizing such existing departments or agencies as he may designate." Given these wide powers, FDR began forming the CCC into a working operation.

Even before the legislation passed, FDR began searching for a man to lead the CCC. He sought an individual who could help settle the controversy with the labor unions. He chose Robert Fechner, a highly touted labor leader. Fechner, born in Chattanooga, Tennessee, had been educated in Macon and Griffith, Georgia, before quitting school at 16 to sell candy and newspapers on Georgia trains. He became a machinist's apprentice for the Georgia Central Railroad, was a union man, and had earned the respect of the common laborer. His hands-on style of leadership led him to visit many of the CCC camps. Fechner saw himself as a "potato bug amongst dragonflies" and was known to proclaim that his clerks were better educated than he. He was considered a common man, living in a modestly priced hotel room when in Washington, D.C. Fechner chose James J. McEntee as his assistant director. These two men ran the CCC until its abolishment.

The Civilian Conservation Corps lasted nine years—until after the outbreak of World War II. Approximately 2.5 million young men, World War I veterans, and Native Americans enrolled. Some 200,000 were African Americans. Many recruits arrived underweight, malnourished, and uneducated. Most left the corps in good health and with at least a high school diploma. Some received college degrees.

Roosevelt's Tree Army planted more than two billion trees, built 13,100 miles of foot trails, restored 3,980 historic structures, spent more than six million man days fighting forest fires, and built 3,400 fire lookout towers.

In Georgia, these young men played significant roles in developing 3 national forests, 3 national monuments, a national battlefield, 12 state parks, and 4 military installations. They planted trees, cleared roads and trails, and built dams, bridges, fire towers, and park facilities while learning a variety of marketable skills. Camps existed in 78 Georgia counties.

Commenting on the legacy of the CCC, social historian Arthur M. Schlesinger Jr. wrote that the CCC "left its monuments in the preservation and purification of the land, the water, the forests, and the young men of America."

Once an active man before polio robbed him of the use of his legs at age 39, Franklin Delano Roosevelt had a love of the outdoors that is seen as a guiding force in the creation of the CCC. Roosevelt was a Jeffersonian in his belief that a rural existence was the best way of life, and Hyde Park, a Hudson Valley estate, was his pride. He spent many hours exploring its forests, gentle hills, and streams, using a specially designed car during his later years. In establishing the CCC, he attempted to save two of our nation's valuable resources—its land and its young men. (Courtesy of the Library of Congress.)

Robert Fechner served as the director of the CCC from 1933 until his death in 1939. Fechner held a reputation for fairness, tact, and patience. A colleague, Connie Wirth of the National Park Service, observed that Fechner "knew little about conservation, but he was a good organizer and administrator." In 1939, Fechner received the Cornelius Amory Pugsley Gold Medal for his achievements in conservation. (Courtesy of National Archives.)

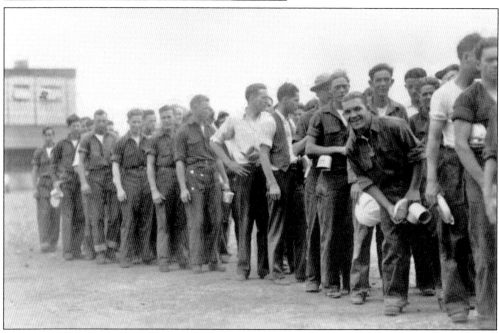

FDR charged officials of the Department of Labor with selection of the first CCC enrollees. W. Francis Persons served as the chief of CCC selection. Persons recruited local relief agencies to find qualified young men. Using a state quota system based on population, the first young men were selected in April. The first camp was at Luray, Virginia, and was named Camp Roosevelt. Here new recruits line up with mess utensils for chow. (Courtesy of National Archives.)

One
Day by Day in the CCC

They came from cities, towns, villages, and farms. Sons from the neediest families were enrolled first. Many had never seen America's wilderness, done a hard day's labor, or earned a wage.

Each enrollee received an army physical, two weeks of conditioning training, and uniforms, including a denim work uniform and a formal uniform. For a month's work, they received $30 in pay, from which they kept $5. The remainder was sent to their family or, if none existed, placed in a savings account. Housing, meals, and medical and dental care came with the job. They enrolled for six months and could reenlist for another six months.

The first enrollees slept in surplus army tents. They built the barracks, the mess hall, the latrines, and every other building needed by the camp. Army officers assigned to each camp ran the day-to-day operations. A project supervisor, chosen based on the camp's work tasks, directed the work. Vital to the success of each camp were the "local experienced men." Usually eight per camp, they provided training for the young enrollees and provided employment for local men, who received the civil service pay rate for their service.

Most enrollees arrived undernourished and underweight. The majority gained from 8 to 14 pounds and about one-half inch in height as a result of good food and hard work. Many of the former enrollees still insist that their most important contribution was the money sent to support their families.

Yet talking with a former CCC enrollee will bring anyone to one conclusion: their enrollment was a final act of desperation following a period of despair and helplessness. Their labors bought them a "rekindled hope for the future and faith in America and its way of life . . . a faith that restores belief in one's physical, mental, and spiritual self, in his associates, and in the future."

Enrollee Ray Johnson stated emphatically, "God created this universe; he gave us spring, with its beauty of flowers, the birds and trees. Now he has given us the CCC and this man Roosevelt. For that, I praise God."

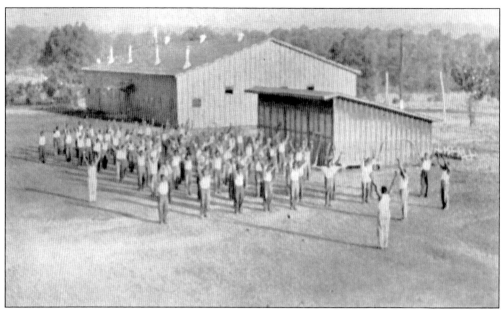

Calisthenics continued after the men arrived at their camps. Organized on April 26, 1933, Company 1464 at Fort Oglethorpe was the first Colored Company in District C of the Fourth Corps. Many of the enrollees came from Memphis, Tennessee. (Author's collection.)

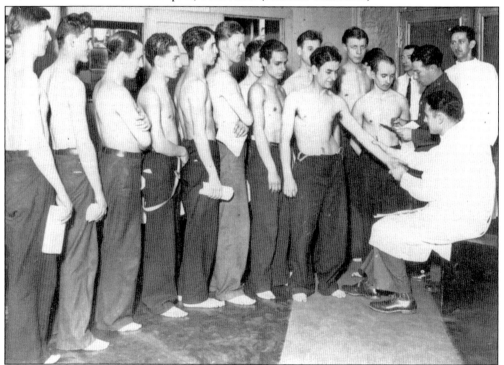

New recruits received a series of injections for various contagious diseases. Rates of disease among the CCC were in most cases lower than the national average for men of the enrollees' age group. This is one from a series of universal photographs issued by the CCC for recruiting purposes. (Courtesy of National Archives.)

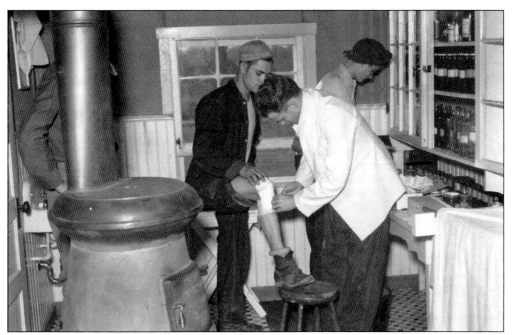

While many camps did not have a physician on staff, a district physician and medical staff were available. At each camp, one or more CCC enrollee trained in first aid treated minor injuries. This is part of the series of universal photographs issued by the CCC for recruiting purposes. (Courtesy of National Archives.)

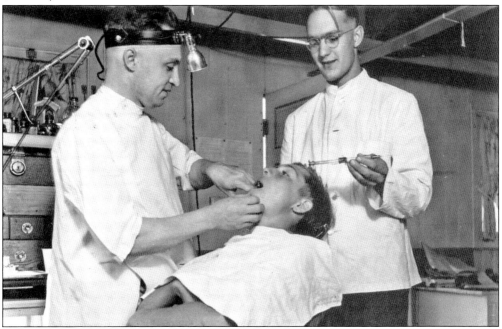

The district dentist and his staff provided care for each enrollee within the district. They traveled from camp to camp, often providing the first dental care these young men had ever received. This is another of a series of universal recruiting photographs issued by the CCC. (Courtesy of National Archives.)

The daily routine at each camp was carried out according to a broad program. Reveille sounded at 6:00 a.m. The men had to be washed, dressed, and ready for physical training at 6:30 a.m. This is one of a series of photographs the CCC issued for recruiting. (Courtesy of National Archives.)

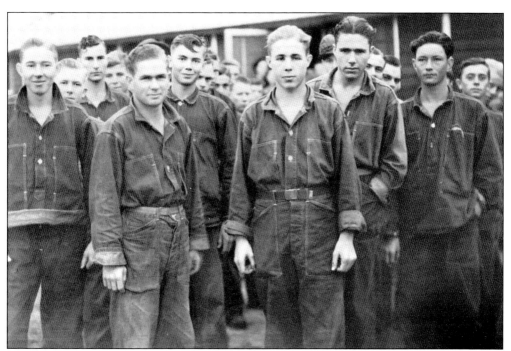

The CCC issued each enrollee a denim work uniform. One enrollee later recalled, "They'd just throw you a pair of pants and a pair of shoes and it didn't make any difference. . . . You'd have to swap around to get something you could wear. One boy was a little bitty feller and I was a pretty big feller . . . and me and him swapped with one another to get one that'd fit us." This photograph was taken at Macon of Company 1426. (Courtesy of National Archives.)

This photograph shows the original dress uniform (left) and the one issued in 1938 at the direction of President Roosevelt. The new spruce-green uniform, designed by the Department of the Navy, was in widespread use by 1939. (Courtesy of National Archives.)

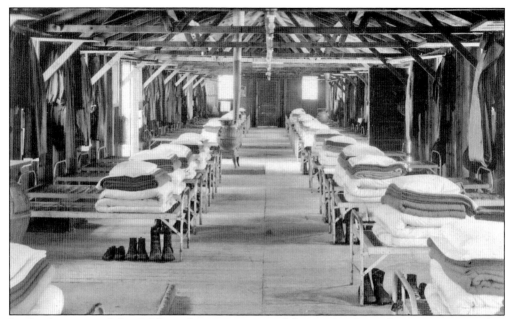

In the first years of the CCC, each camp contained four to five barracks measuring 100 feet long and 20 feet wide. Though built of wood with wood- or coal-burning stoves for heat, some had electricity. Barracks were often cold or hot and more often under-illuminated. This is the barracks at Camp Chipley, Pine Mountain State Park. (Courtesy of the Georgia Department of Natural Resources.)

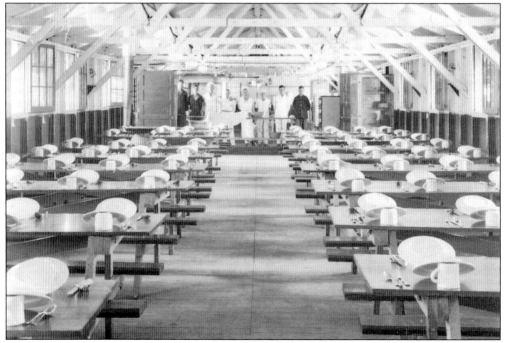

Camp Chipley's cooks stand proudly at the back of their immaculate mess hall on May 12, 1939. FDR often visited Company 4463, located only miles from his Little White House at Warm Springs. (Courtesy of the Georgia Department of National Resources.)

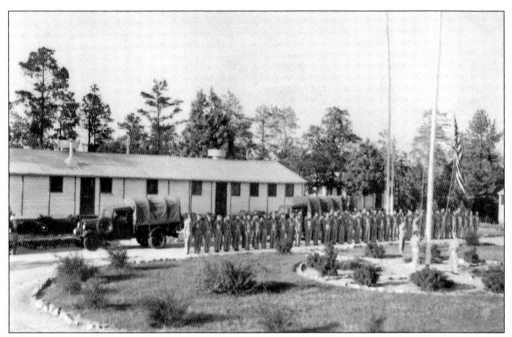

The work day ended at 4:00 p.m., leaving the men with a few hours of free time before the camp flag was lowered, the evening meal was served, and inspection took place. Company 4463 at Camp Chipley lowered its flag for the photographer on May 12, 1939. (Courtesy of the Georgia Department of National Resources.)

The camp commander or one of the other army officers assigned to each camp carried out the evening inspection. This is one of a series of universal photographs issued by the CCC for recruiting purposes. (Courtesy of National Archives.)

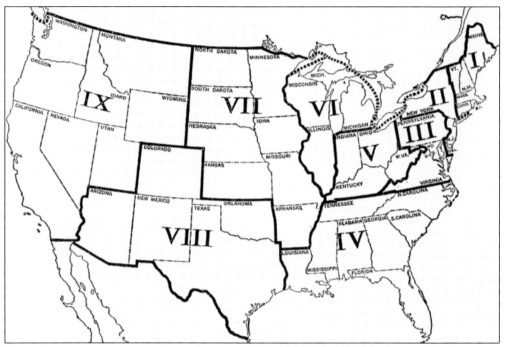

Nine administrative regions made up the organization of the CCC. Each had a corps headquarters. Within each region were districts. Georgia was in the Fourth Corps along with other Southern states. (Author's collection.)

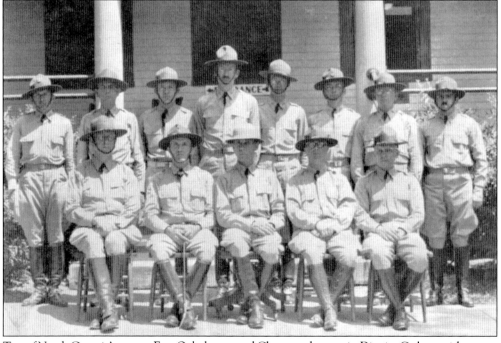

Two of North Georgia's camps, Fort Oglethorpe and Chatsworth, were in District C along with camps from Tennessee and North Carolina. This photograph was taken of the staff of District C, Fourth Corps. These men were regular army officers assigned to the CCC. (Author's collection.)

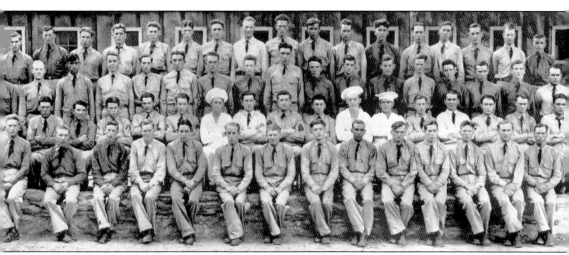

Each year, a district annual was printed for the men. These annuals contained photographs of the company, their commanders, and their work projects, along with camp histories. Selected men from each camp helped write the histories and chose the photographs to be included. This 1934 photograph shows half of the men of Camp 483 (F-7) Chatsworth. (Author's collection.)

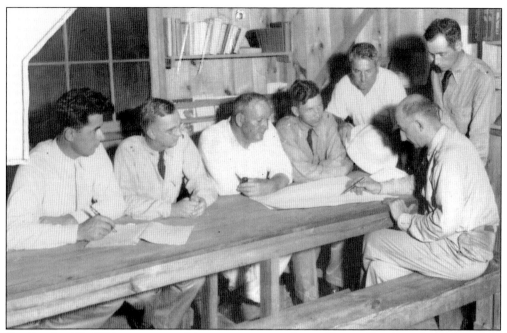

On October 20, 1934, a meeting of the camp commander and his staff at Crawfordsville shows the diversity of age and occupation of the camp leaders. Army officers worked with the National Park Service, U.S. Forest Service, and local foremen to run the camp and direct all work projects. (Courtesy of National Archives.)

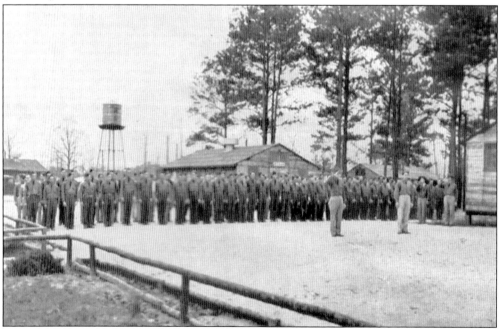

The Fourth Corps' District C was organized at Fort Oglethorpe in North Georgia. The men of this district entered the CCC at Fort Oglethorpe and received their two weeks of conditioning training there before being shipped out to one of the many companies in the district. Here new enrollees stand at retreat. (Author's collection.)

Two

Roosevelt's Tree Army

Nicknamed Roosevelt's Tree Army, thousands of young men quickly learned how to cut diseased trees, clear undergrowth, harvest and plant trees, collect seeds, and fight forest fires. Under the direction of the U.S. Forest Service, 58 camps operated in Georgia during the CCC's lifetime. Fifteen camps were established in the Cherokee, Nantahala, and Chattahoochee National Forests. The remainder of the camps were on private land (see page 126). Another 19 camps operated under the direction of the Soil Conservation Service, often carrying out the same type of work on private lands.

Camps were established in areas where work was needed. Each camp or company consisted of about 200 men. Some camps existed for only one or two periods (six months); others, especially those in our national forests, were created in the early days of the CCC and continued to exist until the CCC was disbanded. F-1, Company 1404, at Suches in Union County, was the first established in Georgia and closed during the last reporting period of 1942, after the beginning of World War II. Some camps finished their work in one area before packing up and moving on to a new work site. Once established, a camp was either junior or veteran, white or African American. The camps remained segregated.

Camps could also have side camps. These temporary camps were built in areas needing particular projects. In side camps, the men often lived in tents that could be set up easily and dismantled when the work was completed.

Camp	CCC Company	Location/Post Office
Cherokee National Forest		
F-1	1404	Suches
F-2	455	Dahlonega
F-3	456	Robertstown
F-7	483	Chatsworth
F-8	485	Blue Ridge
F-11	2417	Dahlonega
F-12	2417	Blue Ridge
F-13	3431	Blue Ridge
F-14	3432	Cleveland
F-15	1443	Hiwassee
Nantahala National Forest		
F-5	458/3427	Clayton
F-6	457	Clayton
F-9	1407	Lakemont
F-10	1443	Clayton
Chattahoochee National Forest		
F-16	3435	Rome

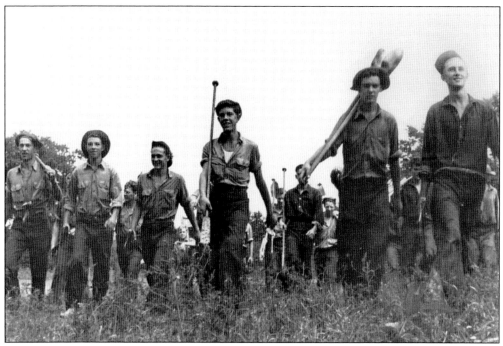

Walter Mead, one of the best-known CCC photographers, captured this image of CCC men headed into the forest at the beginning of the day. Their eagerness to do a day's work showed in their faces. (Courtesy of National Archives.)

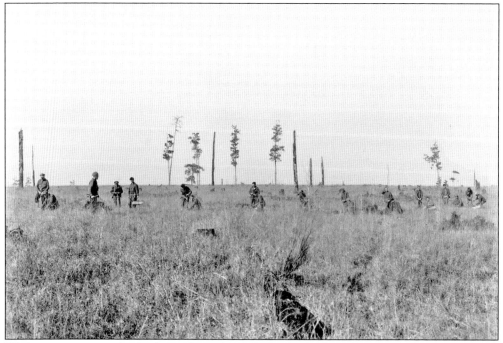

Working across areas that had once been forested, the CCC planted trees in order to restore the landscape and prevent additional erosion. The work often entailed planting thousands of seedlings across broad expanses of land. (Courtesy of National Archives.)

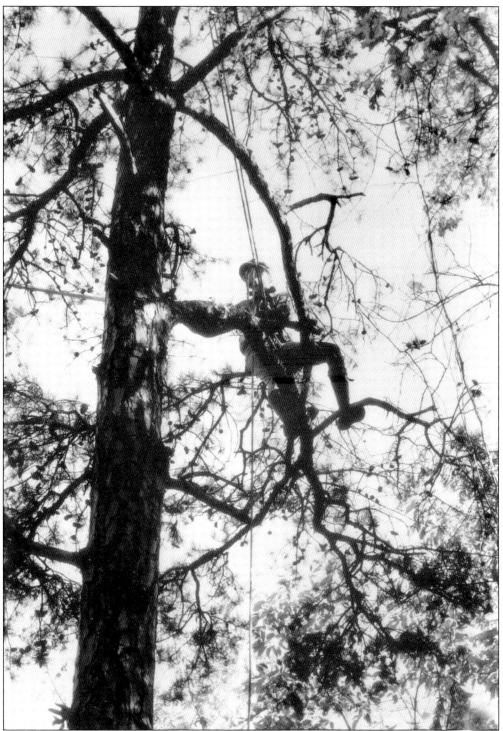
A CCC enrollee collected pine cones by climbing into the tree. The collection of hardwood seeds and nuts and pine cones was an important task when the camps first moved into the forest. (Courtesy of National Archives.)

Here the CCC men use tarpaulins to collect nuts from hardwood trees for planting at various nursery sites selected in each state or region. During the early days of the CCC, a press release using this photograph stated that 726,000 bushels of pine cones and nearly 2 million pounds of hardwood seeds had been collected by CCC reforestation crews. (Courtesy of National Archives.)

CCC nurseries and field stations were established in nearly every region and state. More than five million man days of CCC labor were spent in nurseries during the first few years of operation. Here enrollees are removing seedlings and packaging them for shipment to field planting stations. (Courtesy of National Archives.)

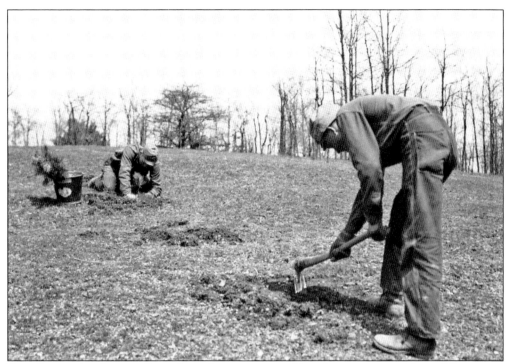
For efficiency's sake, enrollees planted trees in pairs. Together a team could set 600 or more seedlings a day. (Courtesy of National Archives, Soil Conservation Service photograph.)

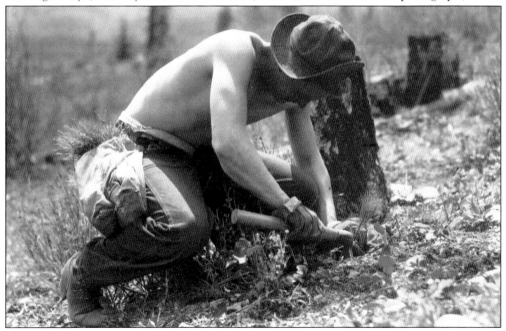
This is one of a series of famous photographs from the CCC days. Here a young enrollee has shed his work shirt and plants pine seedlings in the hot sun. Photographs such as this one appeared in newspapers and recruiting advertisements across the United States. (Courtesy of National Archives.)

CCC men who did forestry work complained about the labor as they rolled into their beds each night. Yet the book *We Can Take It* quoted one man as saying, "If the C.C.C. does nothing more than impress upon us the love for nature, it will be a success. When we better realize and understand nature the world will be a better place to live in, and war will be but a dream." The comic above is from *Historical History: Civilian Conservation Corps*. (Author's collection.)

Three

Building Georgia's State Parks

Just imagine Georgia without the 10 state parks built by the CCC! Originally there were 12, but one is now a city park and the other is in private ownership. Working with personnel of the National Park Service, many states began extensive programs to develop state parks and recreational areas using CCC enrollees. Some parks were developed around historic or scenic sites; others were established in area where recreational activities were extremely limited. Georgia's program included scenic parks like Vogel, Pine Mountain (now FDR), and Cloudland Canyon along with historic sites such as A. H. Stephens, Fort Mountain, and Kolomoki. Little Ocmulgee was created on land that was once swamp, diseased forest, and devastated farmland.

State Parks Developed by the CCC:

Designation	Name	CCC Company	County	Post Office
SP-1	Indian Springs	459	Butts	Jackson
SP-2	Vogel	431	Union	Blairsville
SP-3	Santa Domingo	446	Glynn	Darien
SP-5	A. H. Stephens	478	Taliaferro	Crawfordville
SP-6 and 15	Fort Mountain	488	Gilmer	Ellijay
		447	Murray	Chatsworth
SP-7 and 13	Pine Mountain	1429	Meriwether	Warm Springs
		4463	Harris	Chipley
SP-8	Hard Labor Creek	459	Morgan	Rutledge
SP-9	Chehaw	4461	Lee/Dougherty	Albany
SP-10 and 14	Little Ocmulgee	2419	Telfair/Wheeler	McRae
SP-16	Magnolia Springs	3465	Jenkins	Millen
SP-17	Kolomoki	2419	Early	Blakely
SP-15	Cloudland Canyon	side camp	Dade	Unknown

No photographs have been located from the CCC era at Magnolia Spings, Kolomoki, or Cloudland Canyon.

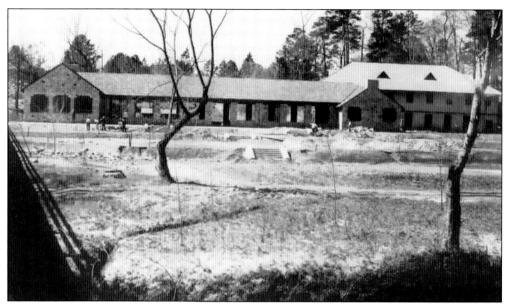

Indian Springs State Park was built by Company 459, a camp established at Fort Benning and moved to Flovilla for park construction work. The administration building, shown here, and several other CCC-constructed buildings still exist. Originally the park contained only 159 acres. (Courtesy of National Archives.)

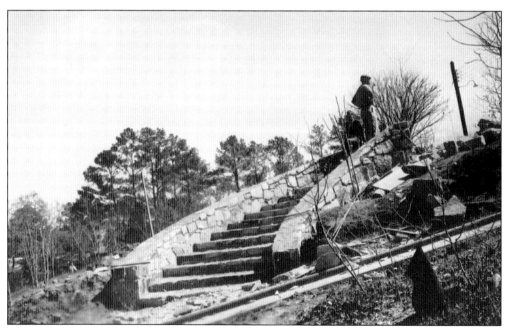

CCC-built parks across the nation display well-built stone structures, such as this staircase leading to the visitor center at Indian Springs. First named State Forest Park and opened in 1927, Indian Springs may be the oldest state park in the nation, as it was acquired from the Creek Indians in 1825 and has been open as a park since that date. (Courtesy of National Archives.)

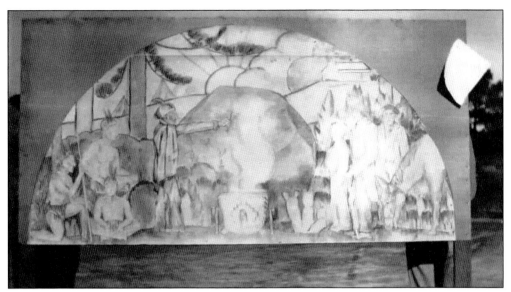

This charcoal drawing of a panel to be carved of wood for the entrance of the visitor center was held in place for the photographer by two hidden CCC enrollees. (Courtesy of National Archives.)

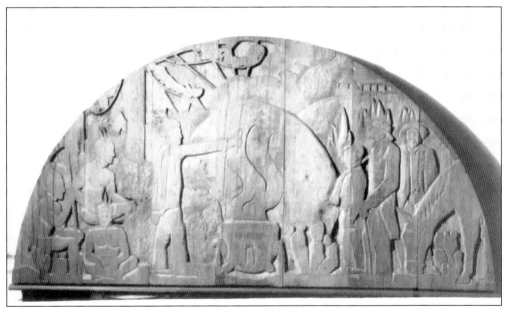

Here the completed wood panel was photographed before being placed in the visitors center museum at Indian Springs State Park. Since these pictures are part of CCC official documentation, it is believed that a CCC enrollee sketched and carved the panel. (Courtesy of National Archives.)

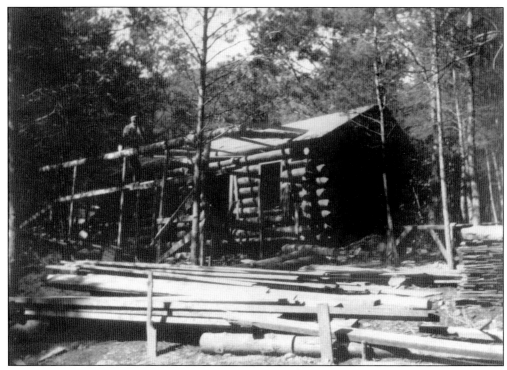

The project supervisor at Vogel State Park took few pictures of the men from CCC Company 431. Here a lone worker is shown during the building of one of Vogel's rental cabins in January 1935. All of the timber and stone used for these cabins was obtained locally by the CCC. (Courtesy of National Archives.)

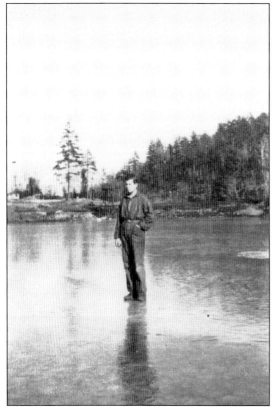

This young CCC worker at Vogel received the high honor of standing on the frozen lake in January 1935. Notice he was not wearing a coat, hat, or gloves, although all of these items were issued to the enrollees who worked year-round on various projects. (Courtesy of National Archives.)

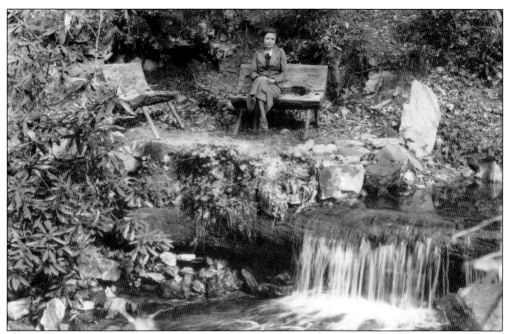

On May 1, 1936, CCC photographer Anderson (first name unknown) visited Vogel and made a series of remarkable photographs. This young woman appeared in many of Anderson's CCC photographs taken in Georgia during May of that year. Anderson enlivened this CCC-built trailside bench with her presence. (Courtesy of National Archives.)

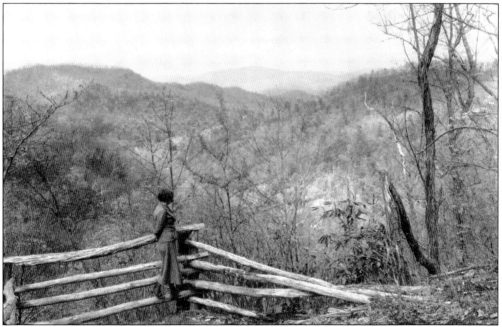

Vogel's CCC trails, including the Notla Falls trail, provided superb vistas, as shown in this Anderson photograph. Trail work at some parks took up a great deal of the CCC's work time, especially in mountainous areas that could not be reached by trucks or any type of heavy equipment. (Courtesy of National Archives.)

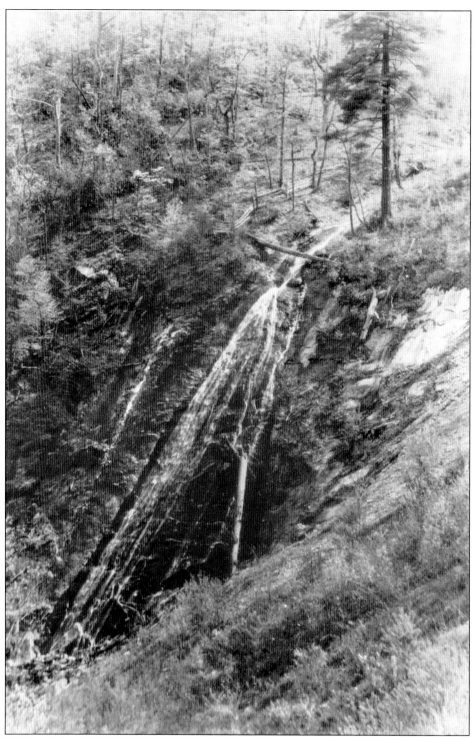

Notla Falls plummeted over a mountain hillside at Vogel. Notice the CCC-built split-rail fence that once protected hikers along the edge of the falls. (Courtesy of National Archives, Anderson photograph.)

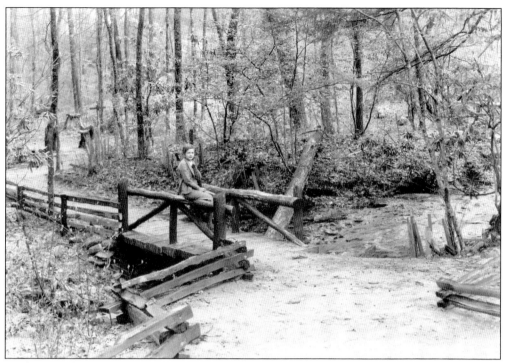

Anderson's photographs at Vogel often featured the trail work carried out on the park's first 259 heavily forested acres. (Courtesy of National Archives.)

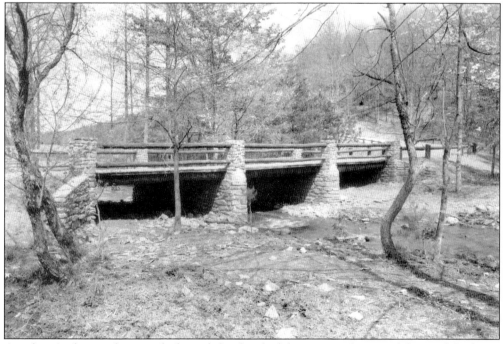

Another Anderson photograph showed the detail of the stonework piers of the truck bridge at Vogel. Some CCC workers learned to cut stone and do other extensive quarry work. (Courtesy of National Archives.)

Blooming trees surrounded two of the visitor cabins at Vogel. These cabins are still reserved heavily all year by Georgians and visitors to the state. (Courtesy of National Archives, Anderson photograph.)

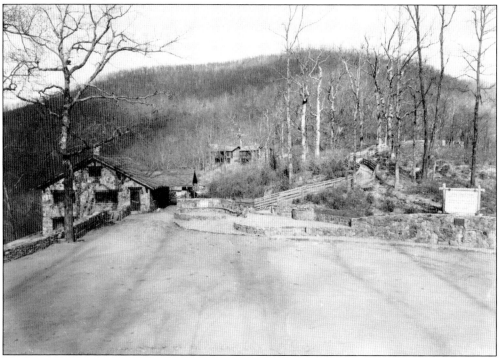

Anderson's photograph of the Neel Gap cabins and entrance provides an excellent view of the mountainous surroundings at Vogel. (Courtesy of National Archives.)

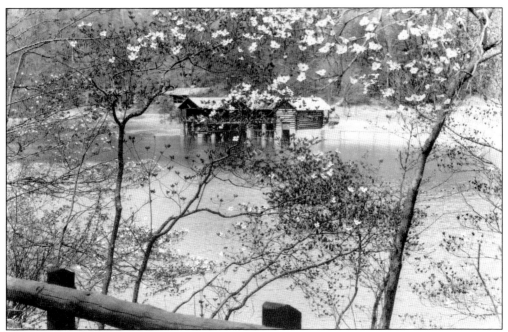

Looking west across Lake Trahlyta, Anderson showcased Vogel's bathhouse through the blooming dogwood trees in May 1936. Vogel is a great place to visit to see flowering trees in the spring and early summer and the colorful leaves on North Georgia's forested mountains in the fall. (Courtesy of National Archives.)

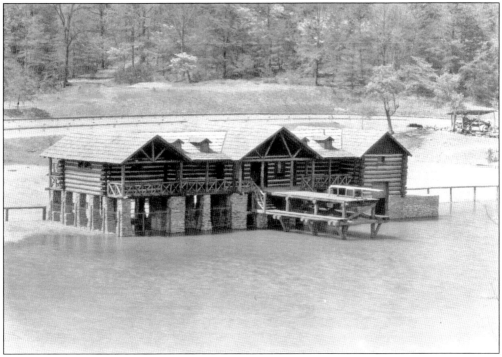

A closer view of the back of the bathhouse shows the diving pier and the lovely stone foundation on which it stands. (Courtesy of National Archives, Anderson photograph.)

A. H. Stephens Historic Park demonstrated the use of CCC enrollees to restore historic structures across the United States. Here Liberty Hall, the home of A. H. Stephens, vice president of the Confederate States of America and one-time governor of Georgia, was restored to its 1875 glory. (Courtesy of National Archives.)

The work of the CCC was dedicated at Liberty Hall on July 18, 1935. The buildings on the grounds of the 217-acre park were designed in the Greek Revival style of Liberty Hall to give the park a uniform and historic appearance. (Courtesy of National Archives.)

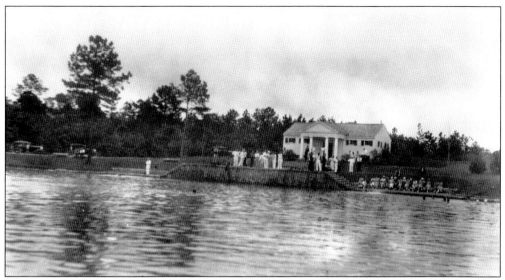

The Greek Revival bathhouse faced Liberty Lake, as shown in this dedication photograph. (Courtesy of National Archives.)

Even the Comfort Station at A. H. Stephens was built in the Greek Revival style of the original house. Using vernacular architecture of the mid-1800s ensured that the park's buildings appeared as though they belonged to the history of the site. (Courtesy of National Archives.)

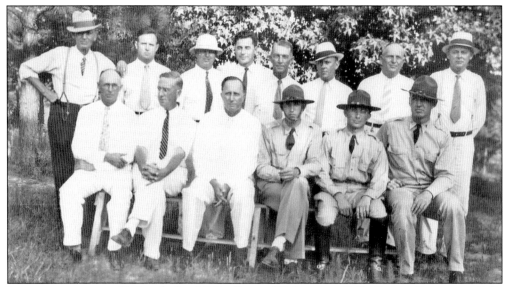
In a narrative report filed with the CCC office in Washington, D.C., Project Supervisor C. B. Ellington submitted this photograph of the camp's supervisory and army personnel. (Courtesy of National Archives.)

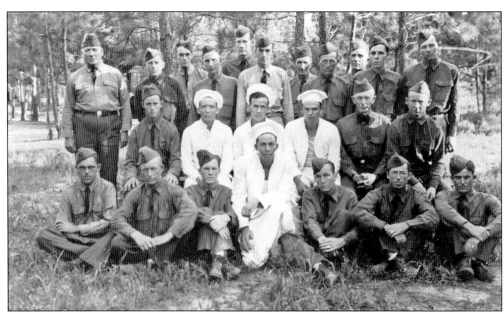
CCC Company 478's leaders and assistant leaders look none too happy in this 1935 photograph. Young men were chosen from each company for their skills and leadership qualities to assume positions of authority. Such training proved to be invaluable, as many of these men assumed leadership roles in the armed forces during World War II. (Courtesy of National Archives.)

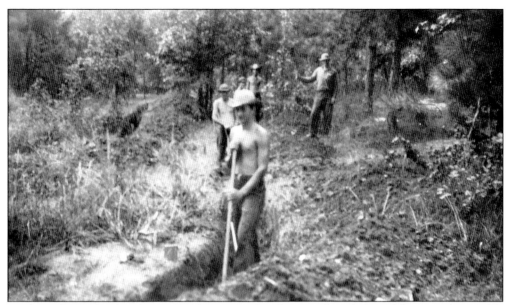

As the park was developed, CCC workers created walking trails and planted flower and vegetable gardens. Local residents provided many of the cuttings of heritage plants, some originating from those planted at Liberty Hall decades earlier. (Courtesy of National Archives.)

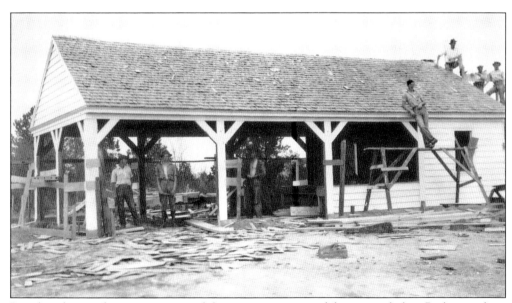

Proud workers and supervisors paused during construction of the picnic shelter. Built away from Liberty Hall so as not to endanger the historic structure, the shelter featured a massive fireplace at one end and two outdoor barbecue pits. (Courtesy of National Archives.)

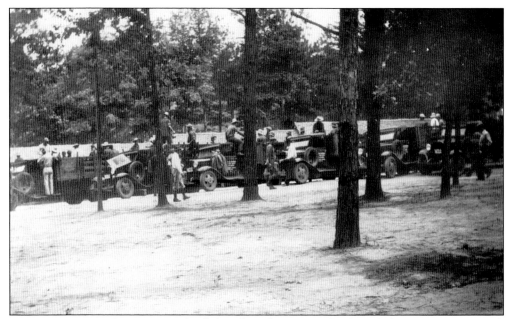

At Fort Mountain, Company 488 loaded tools each morning for their daily trip to various work projects. First assigned to forestry work on private land, Company 488 later spent part of their work time developing the new state park. Fort Mountain, named for the prehistoric Native American–built rock wall on its southern slope, was developed on land donated by Ivan Allen of Atlanta. (Courtesy of National Archives.)

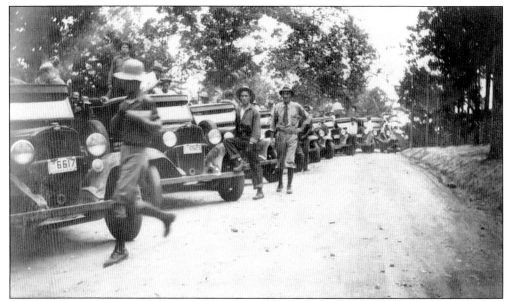

Loaded up and ready to move out, Company 488 traveled about 25 miles each way from their camp to work stations at Fort Mountain, mostly over rough unfinished roads. Later the camp was moved to the Fort Mountain location. (Courtesy of National Archives.)

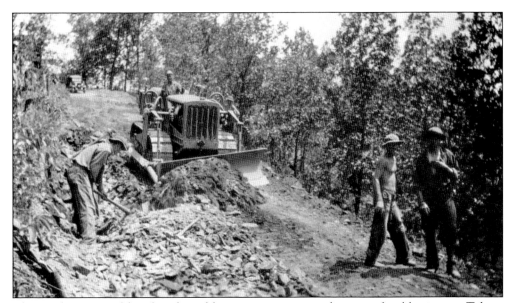

This work crew used hand tools and heavy equipment to clean up after blasting on Talona Mountain Road. Learning to use heavy equipment was a skill that helped many former CCC enrollees find civilian employment after their enlistment period was completed. (Courtesy of National Archives.)

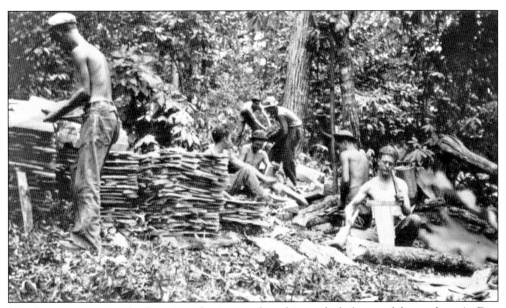

One forest project involved cutting, shaping, and stacking oak shakes used for roofing. At Fort Mountain, these covered the fire tower roof, many of the housing units, and other CCC-built structures. Fort Mountain's CCC company also shipped shakes to other parks. (Courtesy of National Archives.)

Grading along the park's entrance road was another job for the men learning to use heavy equipment. (Courtesy of National Archives.)

Many of the parks employed a variety of local craftsmen such as blacksmiths. This log building housed Fort Mountain's blacksmith shop. Local craftsmen not only crafted and sharpened tools, they also trained CCC workers in the craft. (Courtesy of National Archives.)

Camp personnel such as the project supervisor, the army officers, and other staff members were most often housed in CCC-built structures on each park. After the park opened, these structures housed park personnel and do so even today. This is a 1935 view of the project supervisor's house and the officers' quarters. (Courtesy of National Archives.)

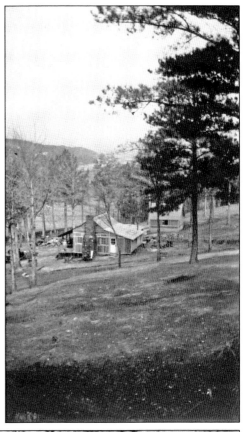

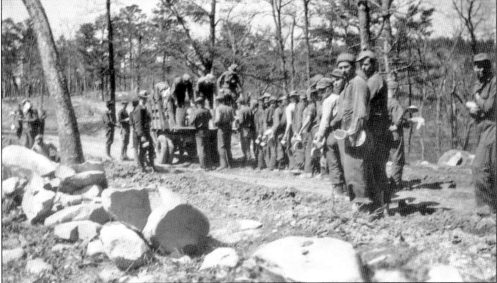

On the work site, the men labored until noon, when the truck arrived with chow. Each man carried his own field mess kit. Noon meals were often sandwiches, cold fried chicken, cold salads, fruit, cakes or cookies, and tea or coffee. During cold weather, hot soups and coffee were brought to the men in the field if they were too far from the mess hall. (Courtesy of National Archives.)

Always proud of their work, the CCC captured this image of some of the first hikers on one of their newly constructed trails at Fort Mountain. (Courtesy of National Archives.)

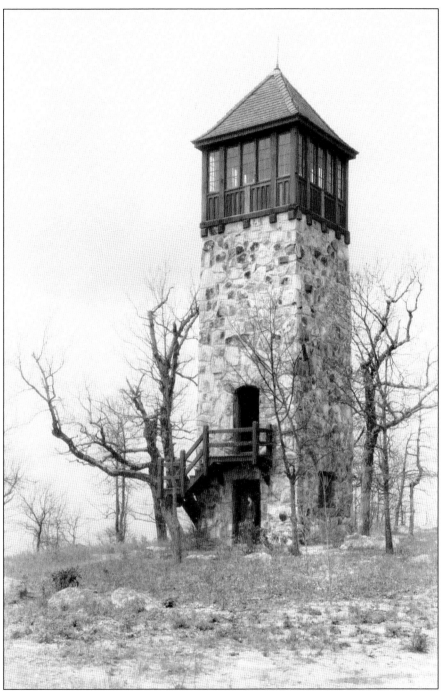
In May 1936, photographer Anderson captured his female companion in the doorway of Fort Mountain's newly completed stone observation tower. The tower stands on the area's highest point. From the top of the tower, visitors could see, to the east, mountain after mountain of the lower Appalachian chain. To the west, one could see more developed areas with cultivated fields, the town of Chatsworth, the smokestacks of Dalton, and Lookout Mountain on the Tennessee border. (Courtesy of National Archives.)

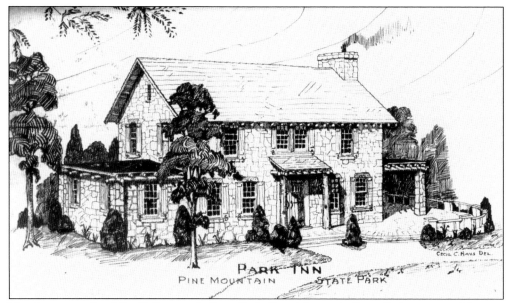

Now known as Franklin D. Roosevelt State Park, Pine Mountain State Park was served by two CCC companies, Camps Chipley and Meriwether. There were grand ideas for the mountain recreation center, including this beautiful stone inn. (Courtesy of National Archives.)

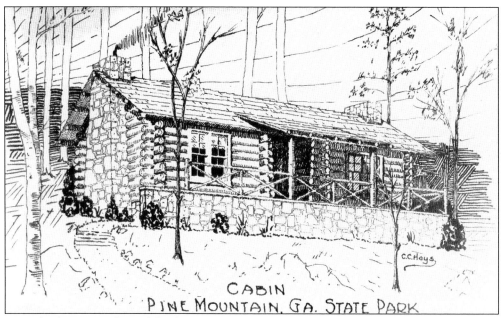

Several cabins were planned for the mountaintop retreat. Unlike the stone inn, they were to be of log construction with stone chimneys and foundations. Six cabins were completed by March 31, 1936. (Courtesy of National Archives.)

Company 4463 occupied Camp Chipley, shown here. These men worked closely with Camp Meriwether in the development of the park. (Courtesy of National Archives.)

The men in Company 1429 lived in nearby Warm Springs at Camp Meriwether. FDR frequently visited the camp while at the Little White House. (Courtesy of National Archives.)

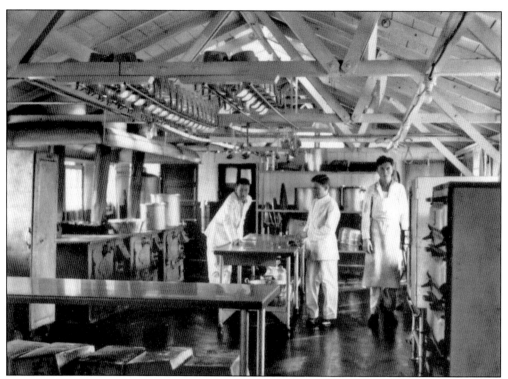

Many of the CCC cooks were members of the company trained by experienced local hires. CCC men received three hot meals a day when possible. In 1936, Project Supervisor C. B. Ellington estimated his men averaged a 20-pound weight gain since joining the CCC. (Courtesy of National Archives.)

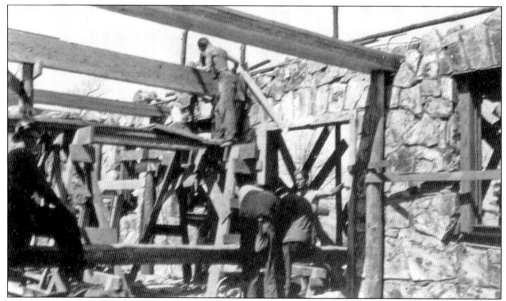

Placing the wood beams for the second floor of the stone inn occupied several days in 1935. In 2007, this building was cleaned and restored much to its original appearance; it now serves as the park's headquarters. (Courtesy of National Archives.)

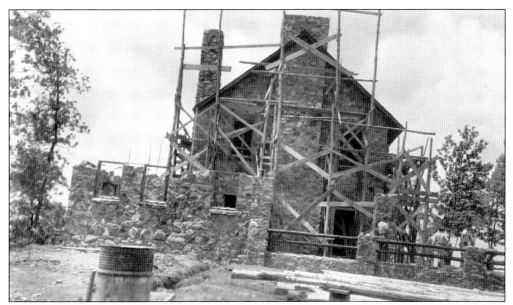

As the work continued, scaffolding was needed to complete the stone work of the second floor and to apply the roof. Learning construction work increased morale, according to the project supervisor. C. B. Ellington stated in an official report that the company could now "face the world with a firm step, heads erect and a smile on their faces." (Courtesy of National Archives.)

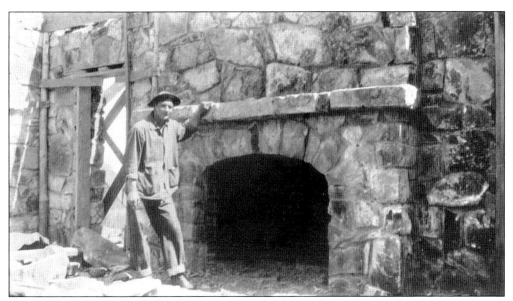

A proud young man stands beside the completed 8-foot-wide fireplace in Pine Mountain's inn. A newspaper article about the work stated that it was completed under the direction of one experienced mason. (Courtesy of National Archives.)

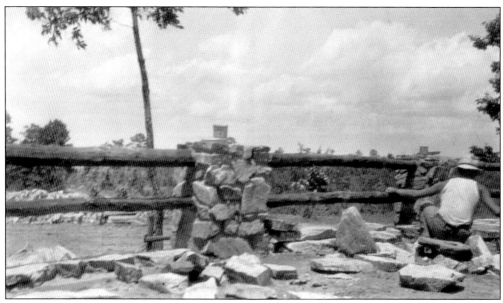

The inn's porches were covered with flagstone. Even today, these beautiful porches provide a great place to relax and enjoy the spectacular views. (Courtesy of National Archives.)

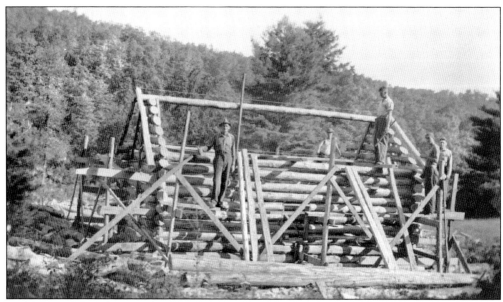

Building with logs demanded a different type of skill. At each park, local experienced men were hired to teach the CCC enrollees a variety of skills. Here the men are working on the park's powerhouse. (Courtesy of National Archives.)

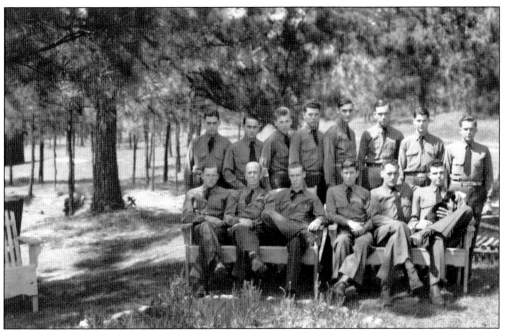

A series of photographs of men from Villa Rica Company 3437 was included in Pine Mountain's semi-annual report. These men worked under supervisor C. B. Gamble to build the furniture used at Pine Mountain's inn. This was a group shot of the furniture-making team; Gamble sits second from the left on the first row. (Courtesy of National Archives.)

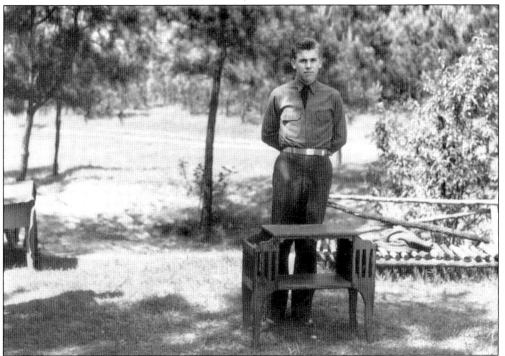

This proud young man shows off an end table built for one of the visitor cabins at Pine Mountain. (Courtesy of National Archives.)

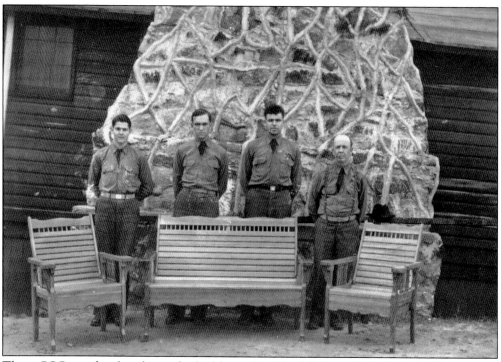

These CCC woodworkers learned a highly marketable skill from C. B. Gamble. (Courtesy of National Archives.)

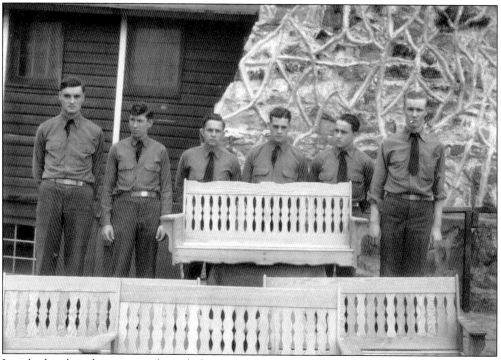

Lovely detail-work swings and porch furniture made the porches of Pine Mountain's cabins a great place to relax. (Courtesy of National Archives.)

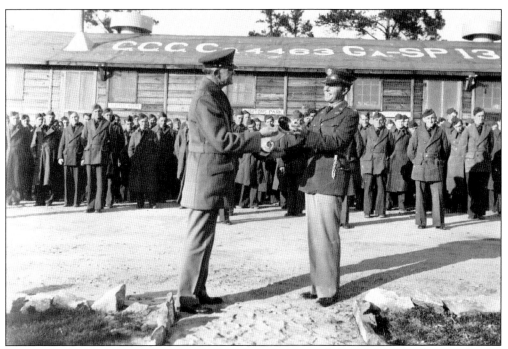

Camp Chipley's commander, 1st Lt. William J. York, received the subdistrict silver cup for the most outstanding camp in early 1936. The cup was awarded every three months. (Courtesy of National Archives.)

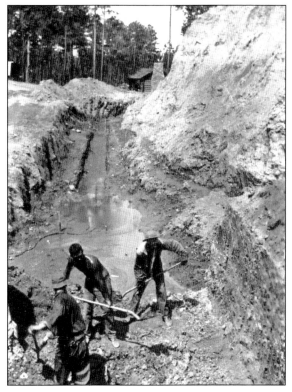

Sluice culvert construction work guaranteed the men would be dirty and tired at the end of the day. CCC men built the water system for the camp as well as all of its buildings. (Courtesy of National Archives.)

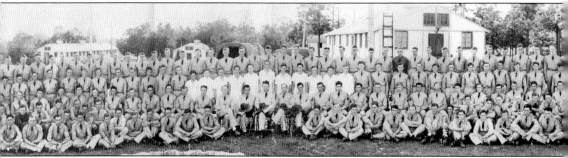
On May 12, 1939, Camp Chipley's CCC company along with their officers posed for this camp photograph. Like Camp Meriwether's men, their morale was reported to be excellent; they were well accepted in the community and were frequently visited by FDR. (Courtesy of the Georgia Department of Natural Resources.)

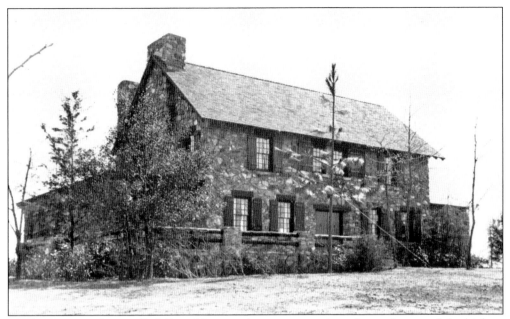

Landscaping newly installed, Pine Mountain's inn sat prominently on the top of the highest ridge, offering visitors exceptional vistas. Today its serves as the Visitors Center for Franklin D. Roosevelt State Park. (Courtesy of National Archives.)

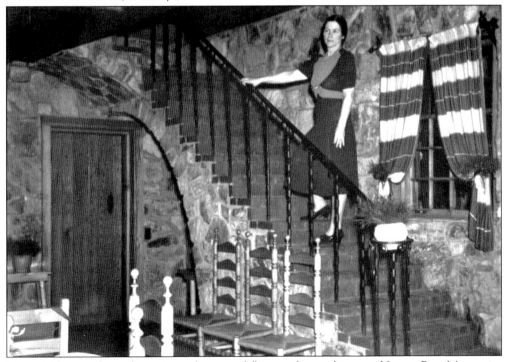

Mrs. Mobley stands on the stairs to the second floor in the newly opened Inn at Pine Mountain. Legend tells that FDR himself designed this beautiful arched stone staircase. All of the lovely wrought-iron work in this building was created by members of the CCC. (Courtesy of National Archives.)

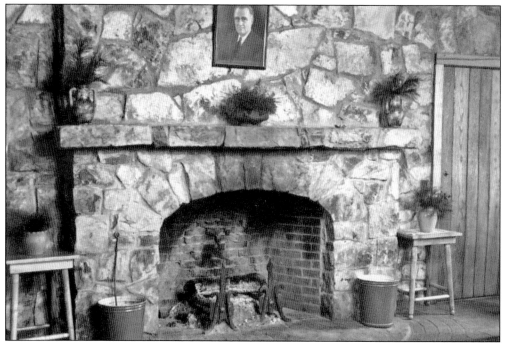

The stone fireplace burned brightly to welcome guests to the Inn at Pine Mountain. FDR's portrait has always hung above the mantle and greeted visitors to one of his favorite CCC parks. (Courtesy of National Archives.)

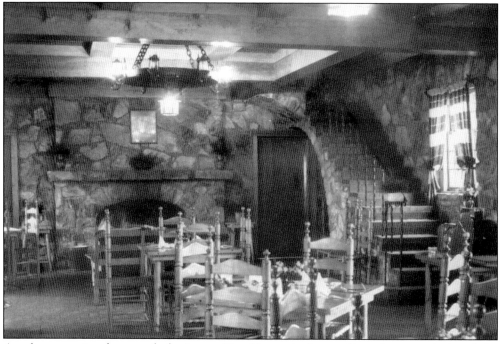

An elegant setting for a meal, the Inn at Pine Mountain featured hanging wrought-iron light fixtures, which can still be seen today. The furniture was created by members of the CCC company at Villa Rica. (Courtesy of National Archives.)

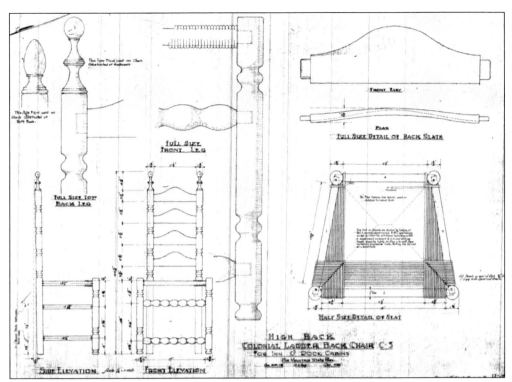

This blueprint for the high-back Colonial ladder-back chairs built for the Inn at Pine Mountain is dated October 1938. The designer is C. C. Hayes. (Courtesy of National Archives.)

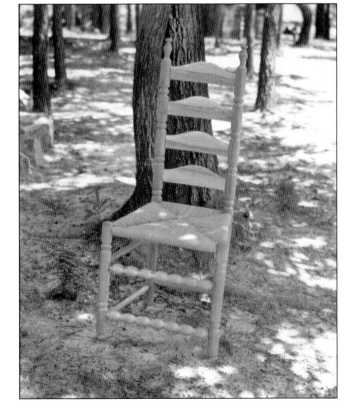

This close-up of one of the newly completed chairs was sent to CCC national headquarters along with the other photographs about the work of CCC Company 3437 at Villa Rica. (Courtesy of National Archives.)

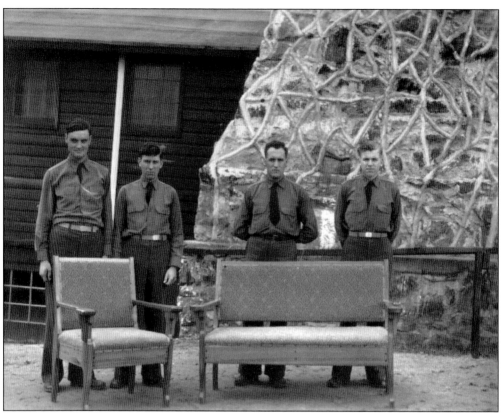
CCC men also learned upholstery skills, as shown in these lovely pieces from Company 3437. These pieces were built for the visitor cabins at Pine Mountain. (Courtesy of National Archives.)

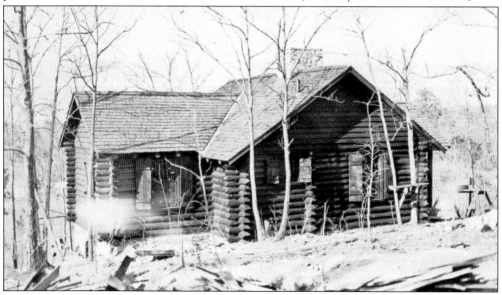
Pine Mountain's visitor cabins still are in use today. These log structures provide tourists with a great place to stay while hiking on one of the many trails that traverse the park. (Courtesy of National Archives.)

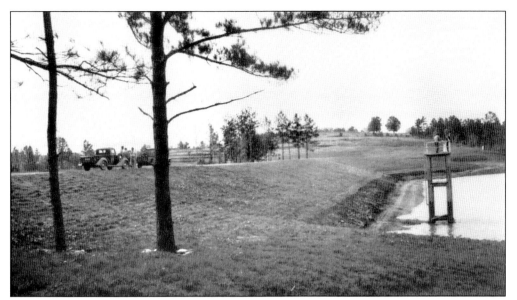

Looking across the recently sodded and seeded earthen dam, the men of Camp 459 probably were sure of how Hard Labor Creek got its name. This gently flowing rock-bottom creek was dammed to create Lake Rutledge and was the site of two CCC-built group camps, Camp Daniel Morgan and Camp Rutledge. (Courtesy of National Archives.)

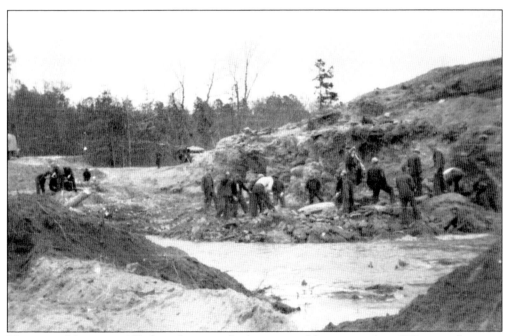

The men of Company 459 cleared trees and other material from more than 200 acres of swampy land to create the basin for Lake Rutledge. Here they are clearing an area used to divert the water during construction of the dam. (Courtesy of National Archives.)

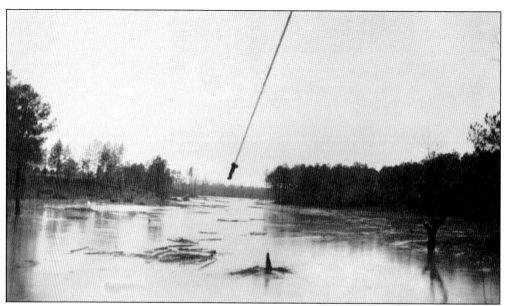

In March 1935, Hard Labor Creek flooded. This picture was taken from Fambrough Bridge. The line drawn from the top points to the flagpole at the camp, which also flooded. (Courtesy of National Archives.)

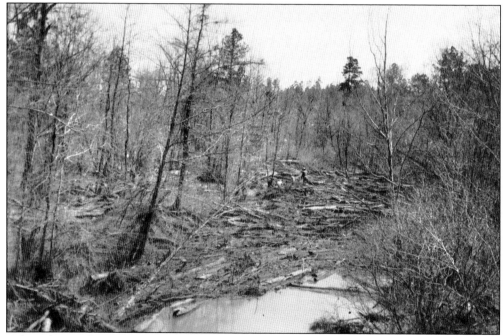

A huge logjam formed directly east of Fambrough Bridge. The logs came from the area of the lake and had been cut prior to the flood. The CCC company had not had time to remove them all before the water began to rise. (Courtesy of National Archives.)

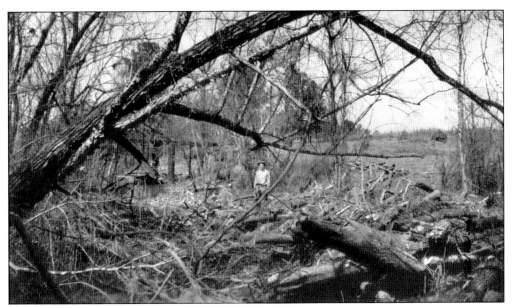
A CCC enrollee stands amidst the logjam. Fambrough Bridge can be seen directly to the left. Hard Labor Creek rose to within a few feet of the bridge floor. (Courtesy of National Archives.)

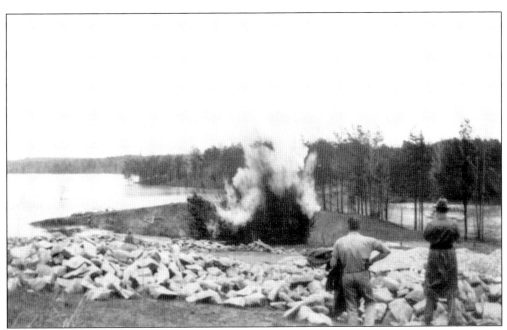
During the flood, it was necessary to shoot or blast the bank of the spillway in order to relieve flooding. The stone in the foreground was to be used for the walls of the spillway. (Courtesy of National Archives.)

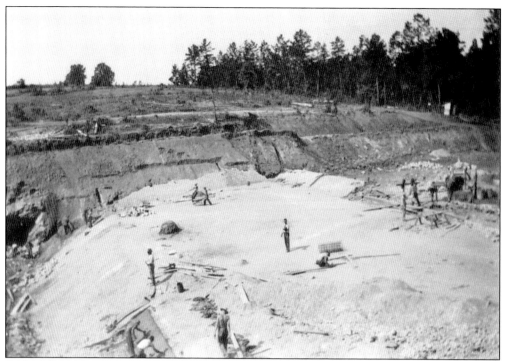
In the fall of 1935, CCC enrollees learned to handle heavy equipment, survey, and make concrete forms during the early days of the dam building project. (Courtesy of National Archives.)

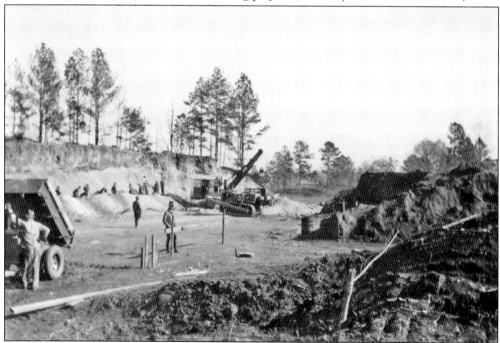
Company 459 had previously worked at Indian Springs State Park. At Hard Labor Creek, the work was quite different. Large crews worked alongside experienced engineers to construct the spillway. (Courtesy of National Archives.)

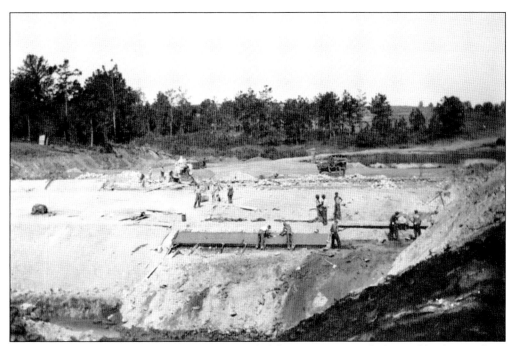
Finally the concrete work began in earnest. Of all of the construction jobs learned by the enrollees, this was considered one of the most desirable. (Courtesy of National Archives.)

Hard labor under a hot sun continued as the men set the side wall forms for construction of the blow-off. A blow-off pipe passes through a dam embankment and outlets at the spillway. (Courtesy of National Archives.)

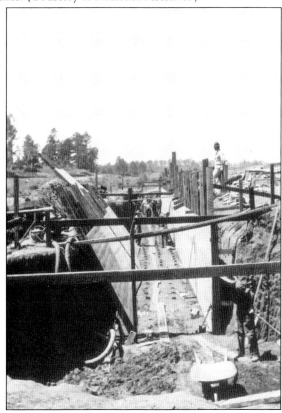

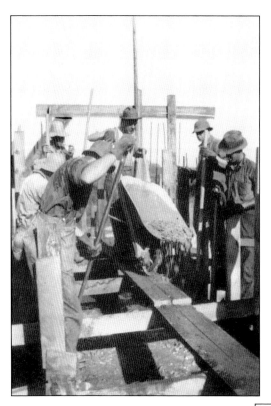

Finally it was time to pour the concrete into the sidewalls of the blow-off. Wheelbarrows and hand tools were used, as heavy equipment could not be used on top of the wooden structure. (Courtesy of National Archives.)

The completed blow-off allowed the creek to continue to flow during the construction of the dam and provided for emergency draw down of the lake during times of heavy rains. (Courtesy of National Archives.)

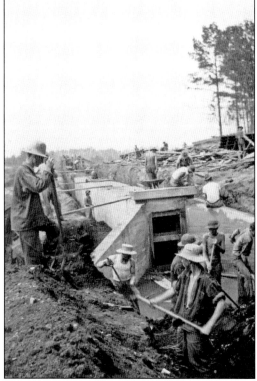

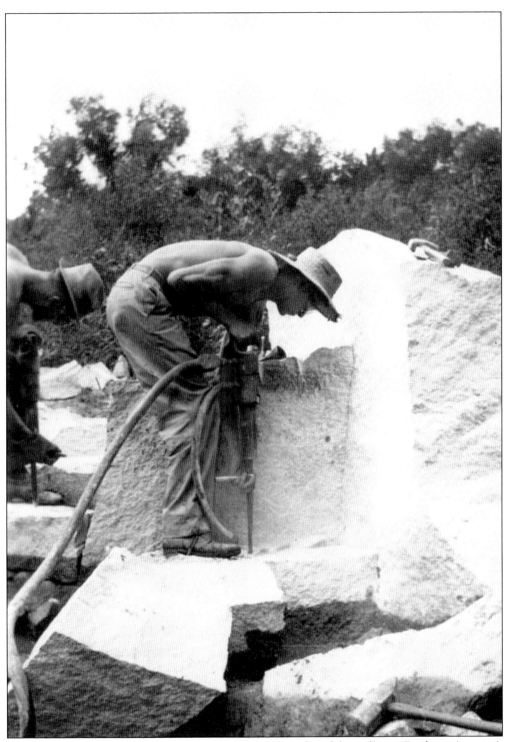

A rock-cutting crew cut granite into blocks to form the sides of the spillway. Teaching America's young men such skills was one of Roosevelt's greatest desires when he created the CCC. (Courtesy of National Archives.)

Wood cut from the lake bed was planked and used to build many of the structures on the park, including this tool shed. This building had a future use at the "girls camp," a group of facilities set aside for overnight camping for girls only. Another camp was built for boys only. (Courtesy of National Archives.)

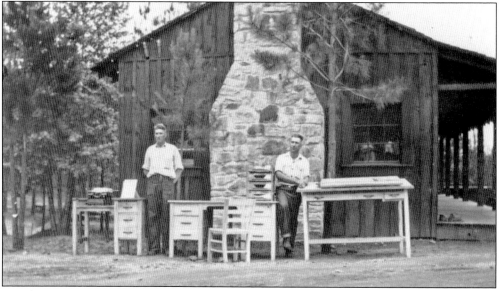

Standing at the chimney end of the tool shed, two CCC enrollees proudly exhibit the office furniture they made on the job. (Courtesy of National Archives.)

Four

THE WORK OF VETERANS

In 1932 and again in early 1933, thousands of veterans of the Spanish-American War and World War I marched on Washington, D.C., demanding early payment of their wartime service compensation pension, which was not due until 1945. These "Bonus Army" men, with an average age of 40, often impaired either in body or mental stability, were among the hardest hit by the Great Depression. They hoped FDR would be more receptive to their demands, for in 1932, they had been met by tear gas, guns, and bayonets sent by President Hoover. FDR and Eleanor greeted these veterans, welcomed them to the Capitol, and listened to their concerns. It was said of the crisis that "Hoover sent the Army, Roosevelt sent his wife."

It was Gen. Frank T. Hines, veterans administrator, who thought of the CCC as a way in which many of these men could be helped. FDR agreed and issued Executive Order No. 6129 to enroll 25,000 war veterans into the CCC with no marital or age limitation. He offered every marcher in the Bonus Army immediate enlistment. Many accepted the offer and became career men of the CCC as generous reenlistment provisions were granted.

Housed in separate camps, some 225,000 veterans worked on CCC projects across the nation. Work was modified to suit their age and physical condition. To many, the CCC became a source of redemption where they could regain their place in society, earn a decent living, and gain a skill. Georgia had at least two veteran camps: P-65 at Jessup worked on forest service projects, and Company 2419 at McRae built Little Ocmulgee State Park.

Veteran camps operated a bit differently than camps for juniors. Veterans who were married often moved their family into the local area and returned home each evening. Single veterans lived in the barracks. While they enjoyed the benefits of two hot meals, breakfast and lunch, many of the men often took the evening meal with their family. Social occasions revolved around family-oriented events, and medical care was often extended, even though informally, to family members.

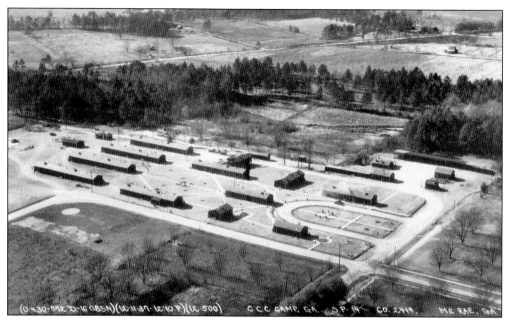

McRae's first camp (P-63) was located on private land and called Camp Tuggle for one of the original enrollees killed by lightning while sitting under a tree. Under the direction of the forest service, these men cleared dead and diseased timber and planted pine forests. This second camp, named Sue-Dan for Sue and Dan McRae, was built within the city limits and had all the city's amenities. (Courtesy of National Archives.)

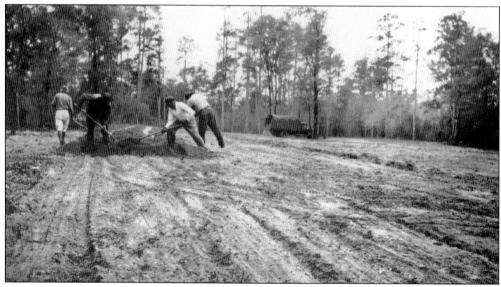

In an area of desolated farmland and diseased forest, the men began building a new state park. They cleared some areas of the park completely. In other areas, old-growth trees were left in place and only the understory was removed. The men contributed over 1,000 man days to forestry projects in the last two months of 1935 alone. (Courtesy of National Archives.)

These veterans planted more than 32,000 transplanted pines from neighboring lands and more than 30,000 pine seedlings and thousands of hardwood seedlings grown at the state nursery. In 1936, Project Superintendent Chester A. Ryals Jr. included this photograph in his report to show an area of the park recently planted with pine seedlings. (Courtesy of National Archives.)

Beginning in 1936 and continuing into 1937, most of the South suffered under extreme drought conditions. Trucks carried water to the field, where barrels were filled and used to water the seedlings daily until they showed new growth. (Courtesy of National Archives.)

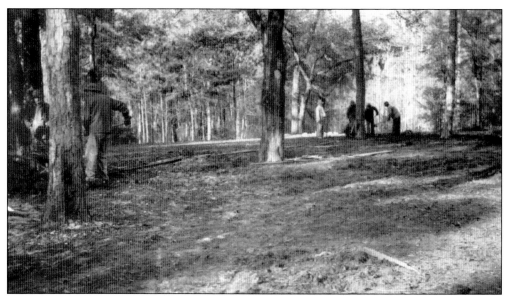
The U.S. Forest Service provided advisors/instructors and landscape architects to each park. While learning valuable forestry skills, the men also learned landscaping techniques. Here an area with some old-growth trees is cleared of undergrowth. Four men, all immune to poison ivy, were placed on the poisonous plant project. (Courtesy of National Archives.)

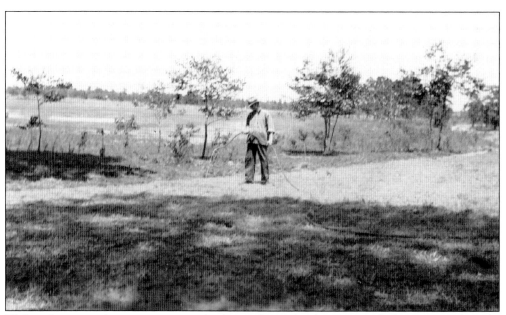
Within the areas where water was easily obtained, new landscaping, including grass and scrubs planted according to an official landscaping plan, was watered daily either by bucket or by hose. (Courtesy of National Archives.)

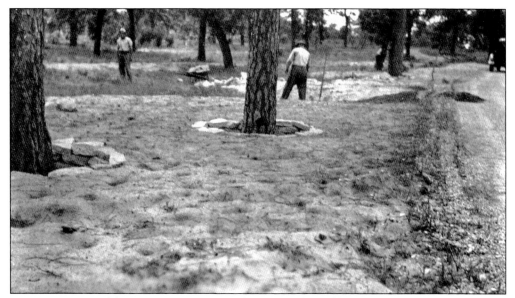

Cut stone, imported from CCC camps in North Georgia, formed landscaping features around older trees and new seedlings. This photograph shows the men working in an area along the entrance road as they placed stone borders around some of the trees. During the drought of the mid-1930s, the men watered the trees by hand daily. (Courtesy of National Archives.)

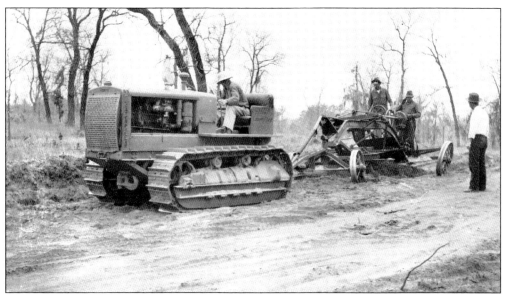

Men with shovels, picks, axes, and bulldozers cleared Little Ocmulgee's main road during the first year of the project. To stabilize the roadbed, it was covered with 6 inches of packed clay and 2 inches of gravel. (Courtesy of National Archives.)

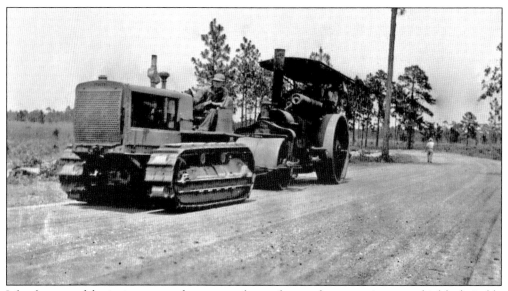

Like the men of the junior camps, the veterans learned to run heavy equipment, a highly desirable skill in civilian markets. Some of these veterans already had such skills, and they quickly rose to supervisor status. Here a veteran enrollee packs down one of the park's roads. (Courtesy of National Archives.)

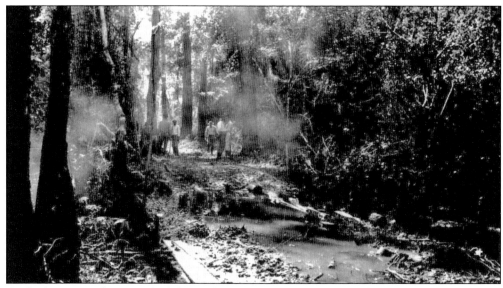

As the forestry work approached the Little Ocmulgee River, the ground often gave way to swamp. In order to create the recreational lake, a large area had to be cleared of all growth. Here pines were clear cut on the edge of the swamp area using manpower and limited heavy equipment. (Courtesy of National Archives.)

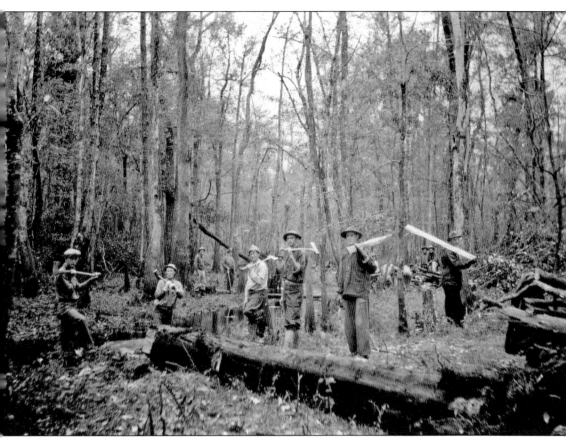

A series of three remarkable photographs demonstrated the conditions under which these men labored to clear the lake basin of all growth. Taken in 1936 by an unidentified CCC photographer, this image illustrates the thick growth the men cleared with manual labor alone. (Courtesy of National Archives.)

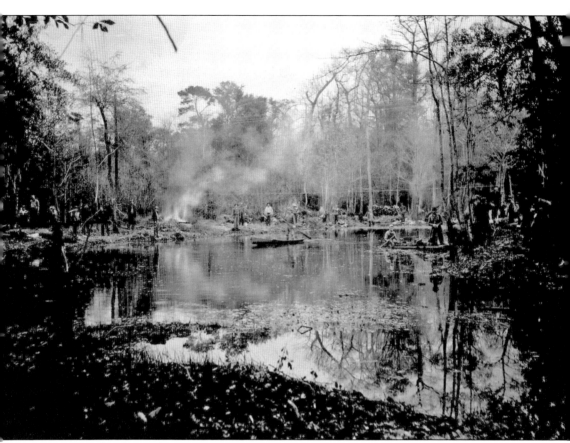

From the official records of the CCC, the story of Little Ocmulgee's dam and lake appears. Project Superintendent Chester A. Ryals Jr. writes on December 2, 1935, "The hindrances to the flow of the water in the channel are being removed . . . old stumps, logs and brush which either grow or have become wedged in the channel of the river . . . are being removed by means of blocks and tackle with man power. The channel is being deepened and widened by means of hand shovels and madlocks [sic]. Five thousand (5000) man days are approved for this project and 2617 have been used to date." (Courtesy of National Archives.)

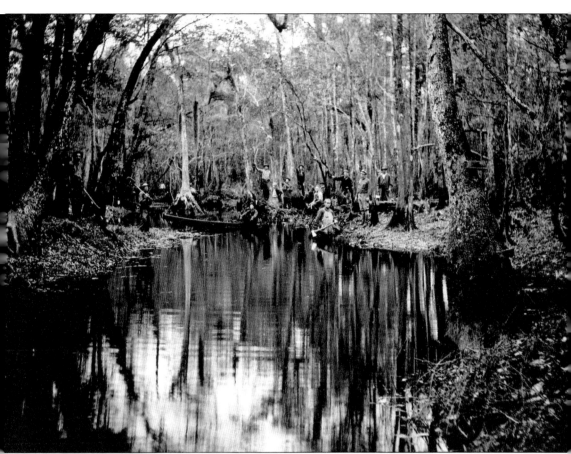

Ryals wrote on February 4, 1936, "The worst winter of many years has hindered the progress on this project. . . . Each enrollee on the project is issued a pair of high top rubber boots, so that he can work in water without getting damp in any way. The channel has been cleared of all hindrances . . . and is now being widened and deepened in the necessary places. All this excavation work is done by hand with the means of shovels. . . . These pictures were taken when the elevation of the water was the lowest it had been in a number of years." Yet, even with low water, the men used canoes and rowboats to reach their work sites. (Courtesy of National Archives.)

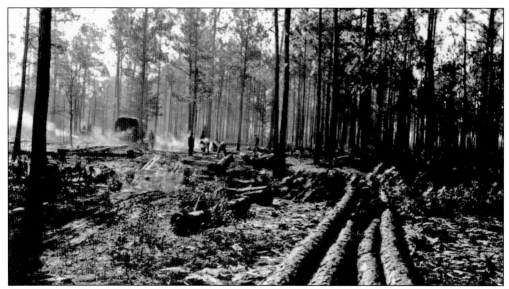

On October 20, 1936, the camp photographer captured this view of enrollees clearing a 15-foot right-of-way on the center line of the proposed dam so that core drilling could be accomplished. A first dam at Little Ocmulgee apparently failed, and testing was needed before construction of the second dam could commence. (Courtesy of National Archives.)

The men used logs removed from the lake basin to cover low swampy areas along the road so the drill could be moved into position. All of this work was done by hand, as the area was too swampy for heavy machinery. (Courtesy of National Archives.)

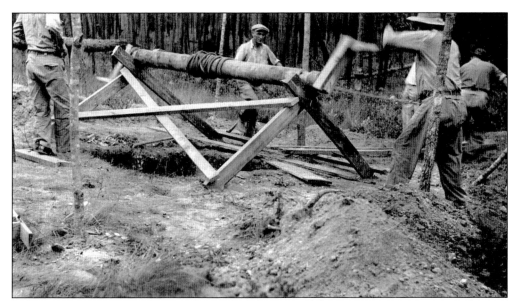

Investigations, called soundings, at the site of the proposed dam began in January 1936. The men dug several tests using drills and casings, and samples were taken for analysis. This photograph shows men digging a test pit in the area of the proposed dam on July 14, 1936. (Courtesy of National Archives.)

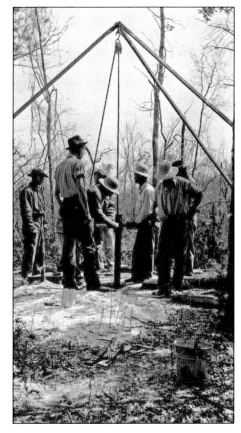

Finally a core drill, which could bore a hole to a depth of over 1,000 feet and was capable of bringing up unbroken cylindrical cores, arrived at Little Ocmulgee. Under the direction of driller V. C. Mickle and assistant driller William Sasser, formerly a CCC enrollee at Chehaw, Georgia, the final tests were conducted at the proposed dam site. Because of its costly nature, numerous revisions of the plans held up dam construction until late spring of 1938. (Courtesy of National Archives.)

Other projects at the park required the men to remove an old Scout camp and several tenant houses. They razed the buildings and cut timber. Selected men were trained to hew out timber for the log buildings to be constructed on the site. Approximately 125 timbers of varying lengths were hewn for the construction of the combination building. (Courtesy of National Archives.)

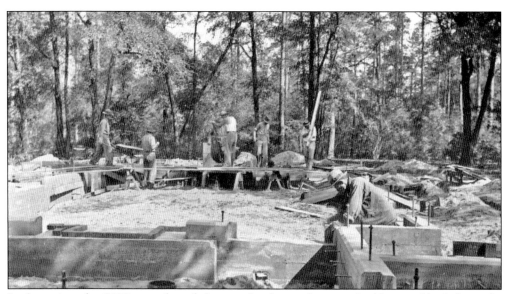
In the spring, the CCC men cleared the area for the combination building and built forms for the foundation of what was to become a large log building. Once finished, it would house a small restaurant and social gathering place. Although they were issued the mandatory CCC uniform, many of these men wore a more formal hat of the kind to which they were accustomed. (Courtesy of National Archives.)

Once a construction foreman was appointed to the park in the spring of 1936, actual construction began. Work building the forms for the concrete required precise measurements and general carpentry skills. (Courtesy of National Archives.)

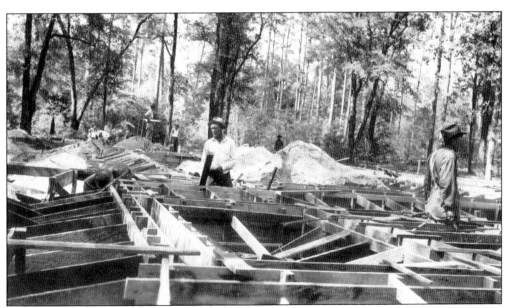

Here the men set the forms for the foundation of the walls. Working from official plans for the building drawn by CCC architects, the project supervisor directed the daily work. While many CCC buildings look alike, each park was designed with some distinctive characteristics to its buildings that ensured its buildings would not look exactly like those in every other CCC-built park. (Courtesy of National Archives.)

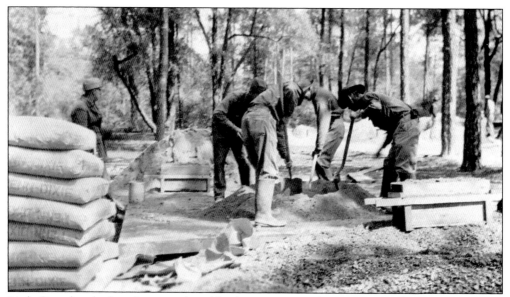

Little Ocmulgee had no shortage of sand for the concrete work or experienced men to oversee the labor. Project Superintendent Ryals reported that the camp's veteran enrollees included a civil engineer, a landscape architect, a carpenter foreman, a surveyor, a labor foreman, a mechanic, and a blacksmith. Many of these skilled veterans took supervisory roles with the CCC after their initial term of enlistment. (Courtesy of National Archives.)

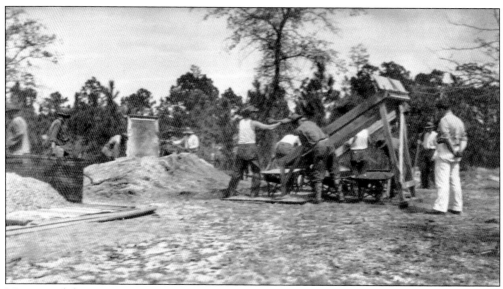

Mixing and then pouring concrete into the forms was work carried out almost entirely without mechanical equipment. The concrete wall was rubbed with Carborundum stone to give it a more natural appearance. (Courtesy of National Archives.)

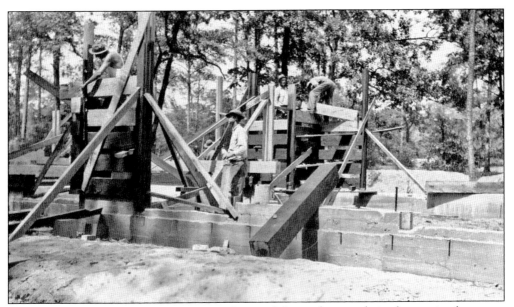

Finally the log walls began to rise. Dovetailing each log to fit securely in the previously set row required the use of hand tools. This work continued throughout the spring and into the hot summer of 1936. (Courtesy of National Archives.)

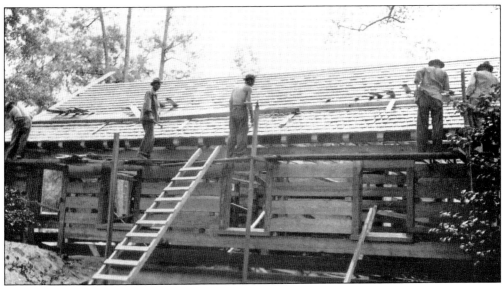

Setting the rafters and trusses began on June 19, 1936. On July 20, the men began the work of shingling the roof. After the sheeting was in place, the men applied the cypress shingles beginning on what was then the kitchen end of the building. Enrollees made the shingles at Little Ocmulgee and even exported some for buildings at North Georgia CCC parks. Other workers applied asphalt pitch caulking between the timbers. (Courtesy of National Archives.)

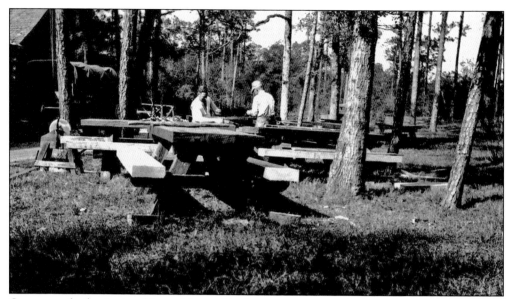

Carpenters built picnic tables, cabins, cabin furniture, a picnic shelter, a bathhouse, and even the project supervisor's house. Many of these buildings are still in use today at Little Ocmulgee State Park, which opened to the public in 1940. The lake is still a local recreation spot, and the park now has a beautiful lodge and golf course. (Courtesy of National Archives.)

The early morning sun breaks through the trees on the combination building, a testament to the hard work of a group of veterans who created a park out of wilderness while regaining their own strength and self-esteem. Today the CCC's combination building is the park's visitors center and houses a CCC exhibit. (Courtesy of National Archives.)

Five

CHEHAW AND SANTA DOMINGO

Georgia's CCC developed two additional state parks, one at Albany called Chehaw and the other near Darien called Santa Domingo. Santa Domingo was one of the earliest turned over to the state and consisted of 370.5 acres. Developed by Company 446 on private land, the park centered on tabby ruins believed by many to be one of the Spanish missions of the Georgia coast. Cator Woolford owned the lands that had been the Elizafield Plantation and presented them to the State of Georgia on November 22, 1935.

Santa Domingo was a state park for approximately 10 years before being turned over to Glynn County for the formation of Boys Estate in 1945. Like the famous Boys Town, the estate allowed the boys to elect their own city officials and run its government. Each boy did his share of the work, and they lived together in communal cottages with a house mother. The grounds are now privately owned and are a youth treatment center known as Morningstar Youth Estates.

Chehaw State Park at Albany originally contained 605 acres. Named for the Native Americans who once lived in the area, the park was one of the last to be developed by the CCC. In 1975, the park was one of several chosen to be closed by Georgia's Department of Natural Resources. Today it is called the Parks at Chehaw and includes a wild animal park, campgrounds, BMX bicycle track, the Creekside Education Center, nature trails, and a play park.

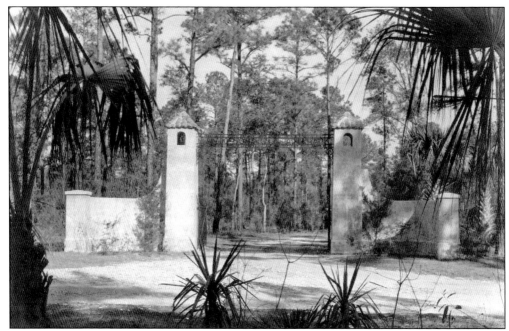

The Spanish-influenced entrance gates of Santa Domingo welcomed visitors to the new state park as early as 1935. In January 1936, CCC photographer Anderson visited the park with his lovely companion. All of the photographs of this park come from his visit. None include CCC enrollees. (Courtesy of National Archives.)

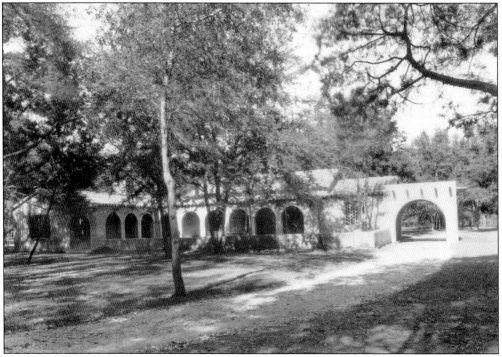

The park's combination building with its arched portico and Spanish influence was described by Anderson as "beautiful from any angle." (Courtesy of National Archives.)

The chimney of the threshing mill stood among bare vines in the winter of 1936. Pieces of 19th-century machinery found among the ruins proved the building was a mill for threshing rice or grinding cane when the land was part of Elizafield Plantation owned by Dr. Robert Grant, a wealthy planter-physician from South Carolina. The plantation was named for Grant's Scottish mother. (Courtesy of National Archives.)

The park's paths and trails wound among saw palmetto and live oaks covered in Spanish moss. Trail markers, like this one to the ruins, were elegant in design and made by CCC blacksmiths. (Courtesy of National Archives.)

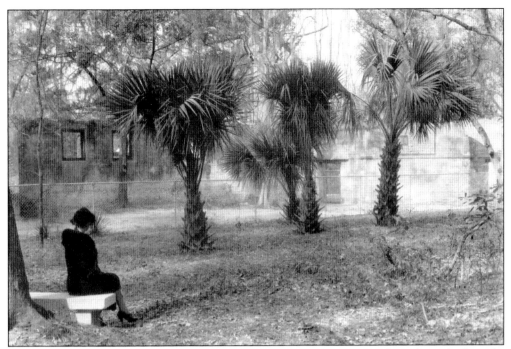

CCC enrollees conducted archaeological investigations at the octagon-shaped ruin looking for remains of the Spanish mission legend said existed at the site. Once the ruin was cleared and stabilized, a fence was built to protect it. (Courtesy of National Archives.)

Reflected in the pool of the lagoon, Anderson's companion enjoyed the trails and lovely views accorded this park by the efforts of the CCC. (Courtesy of National Archives.)

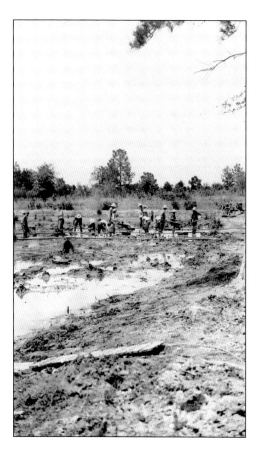

In developing Chehaw as a recreational park for the city of Albany, CCC Company 4461 cleared a number of channel lagoons along a creek edge that were navigable by small boats when completed. This photograph was dated July 31, 1936. (Courtesy of National Archives.)

A large portion of the work time was spent landscaping the park. Project Superintendent A. F. Sweetland noted that the area along the creek was planted with "redbud, crepe myrtle, dogwood, and native shrubs . . . giving a riot of color." Here CCC workers plant Bermuda grass in an area already being used by picnickers. Additionally, some 45,000 pine seedlings were purchased for the park from a local nursery. (Courtesy of National Archives.)

Using a concrete mixer loaned to the company by the City of Albany, the men poured a manhole for the sewer line. As the CCC developed parks, they were expected to carry out all of the work, including running water and sewer lines. In the background is the newly completed public latrine. (Courtesy of National Archives.)

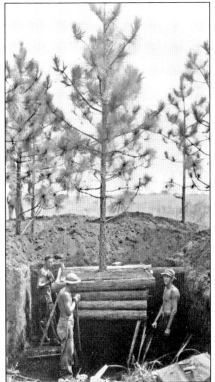

Superintendent Sweetland used this photograph in his 1936 report to show the size of pines being transplanted in their landscaping program. By digging underneath and supporting the trees with timbers, the men could stabilize the entire clay ball around the roots. The trees were then loaded on a trailer pulled by a tractor and hauled to their new locations. (Courtesy of National Archives.)

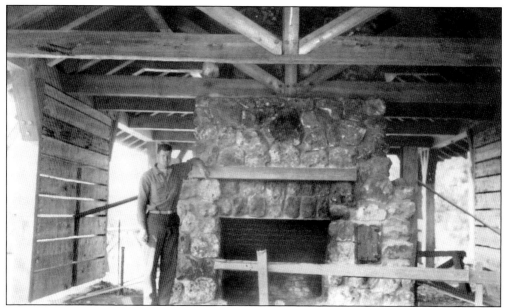

This newly completed fireplace in the picnic shelter contained a Dutch oven on one side. The fireplace opens to both sides so that the shelter can be used by two groups. It was constructed of native limestone. (Courtesy of National Archives.)

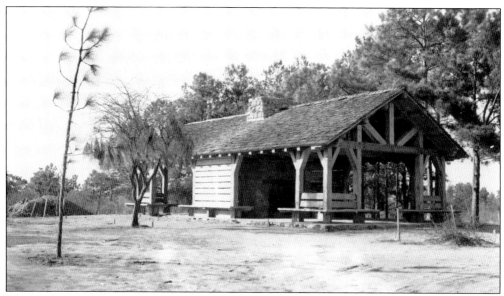

The newly constructed picnic shelter was one of several structures created for the camp. CCC men made approximately 50,000 cypress shingles and 600 cedar timbers for construction projects at the camp.

Six

IMAGES FROM GEORGIA'S OTHER CAMPS

Despite their name—Civilian Conservation Corps—and their popular designation as Roosevelt's Tree Army, the enrollees of the CCC also carried out a variety of work projects involving protecting wildlife, soil erosion, and animal husbandry. Certain camps maintained the supply depots for camps within their district. Others carried out vehicle maintenance. Even at camps where the work focused on forestry projects, the men gained a wide variety of experience and education conducting the business of the camp.

While official CCC records at National Archives contain a wealth of information on those camps that built state and national parks, for some of the forestry or soil conservation camps, practically nothing exists. Their presence at a location, their company name, and a few photographs may be all that can be found to testify to their brief existence. Yet these tidbits of information allow for a more comprehensive view into the era of the CCC.

This chapter will focus on the camps for which little can be found. One of the richest sources of information is the district annuals prepared for the men of the CCC each year. Today, as many former CCC enrollees reach the end of their lives, some of these books are donated to museums and archives. Others unfortunately are discarded. A few become available on auction sites such as eBay. These annuals provide interesting histories along with photographs of the companies, their work projects, and camp activities. Much of the information provided in this chapter came directly from CCC annuals found at the Georgia Archives and in the author's personal collection.

Some state archives, the National Park Service, CCC-built state parks, and other organizations have taken it upon themselves to compile oral histories from former CCC enrollees. These histories provide CCC-era historians and the interested public with firsthand accounts of their days in the corps. At several Georgia state parks, including Little Ocmulgee and Franklin D. Roosevelt, recently installed CCC exhibits feature audio programs using these remembrances, giving the CCC a voice that is all its own.

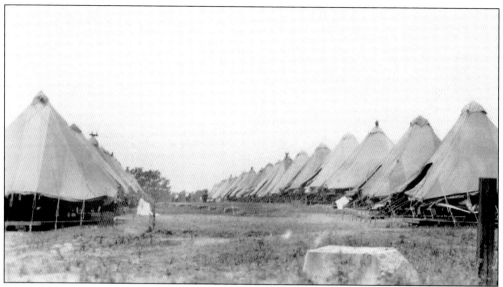

Fort McPherson opened as a CCC District B (Fourth Corps) Headquarters on July 1, 1933, with 300,000 men in camp. The men lived in tent camps during their conditioning period administered by army officers. Some of these men remained at Fort McPherson and established the supply company under the direction of a number of experienced logistical supervisors. The supply company was quartered in the recruit barracks opposite the post hospital. (Courtesy of National Archives.)

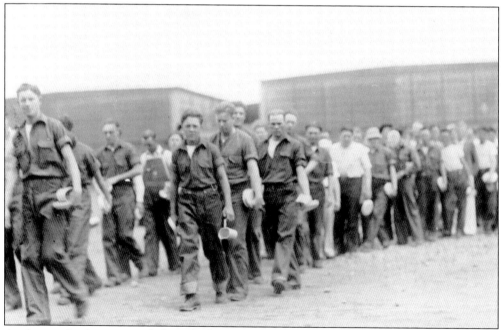

As thousands of men moved through the conditioning camp, work camps were established in Georgia, North Carolina, and South Carolina. In the early days, thousands of army officers and men developed the program and system for organizing work camps. Army buildings at the fort were pressed into service as supply points, warehouses, in-processing facilities, and mess halls. These new enrollees are lined up for chow. (Courtesy of National Archives.)

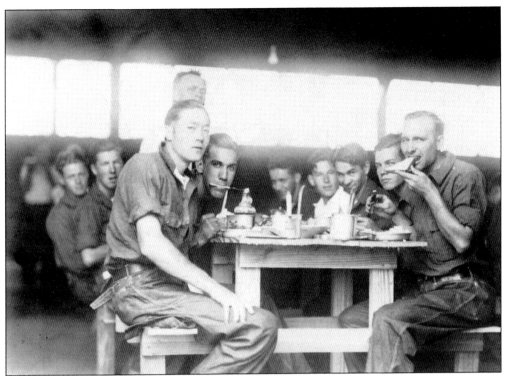

Using mess kits and sitting on wooden benches, the men clowned for the camera during their conditioning period at Fort McPherson. (Courtesy of National Archives.)

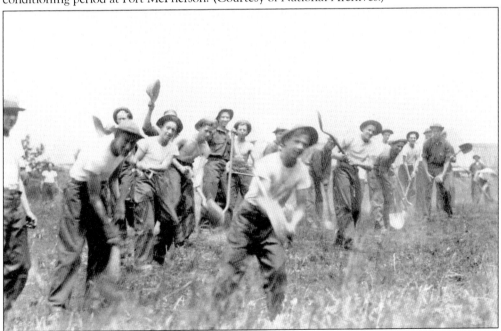

It appears this conditioning group also needed instruction in how to use the basic CCC tool—a shovel. However, they needed little instruction on how to pose for the cameras. (Courtesy of National Archives.)

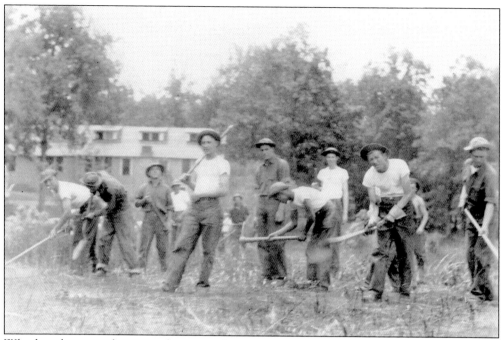
Whether the same day or a subsequent day, the pickax was the next tool to be introduced. (Courtesy of National Archives.)

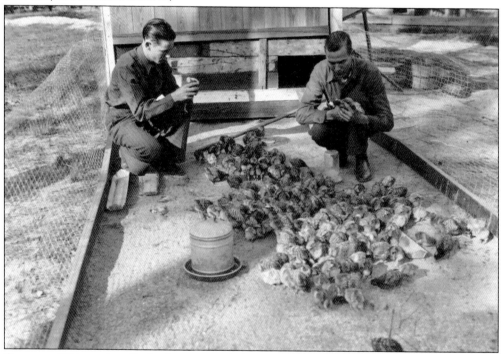
Company 1424 was described as having wanderlust since the company moved so often. Organized at Fort Benning, they first went to Waynesboro, then moved to Sylvania, where they spent much of their time fighting forest fires. Then in May 1934, they moved to Baxley. This photograph shows two of the enrollees with their poultry raising project. (Courtesy of National Archives.)

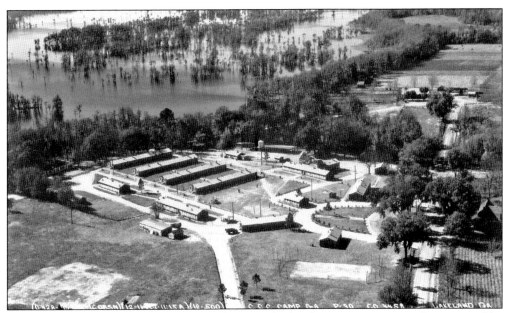

After the first few months, there came to be a standardized camp arrangement that was used by most CCC companies where possible. Depending on the lay of the land, barracks, mess halls, headquarters, educational buildings, and other structures were laid out in an orderly manner. This is Camp P-90 at Lakeland. (Courtesy of National Archives.)

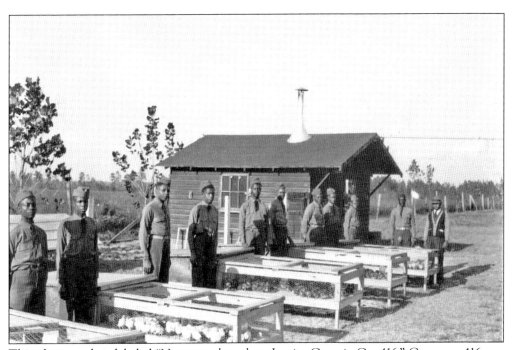

This photograph is labeled "Negro poultry-class, Lanier Georgia Co. 416." Company 416 was stationed at Fort Benning near Harmony Church Hill at Camp F-B-2. They arrived at their camp at only about three-quarters strength because of an outbreak of measles at Fort Benning before their conditioning period had ended. (Courtesy of National Archives.)

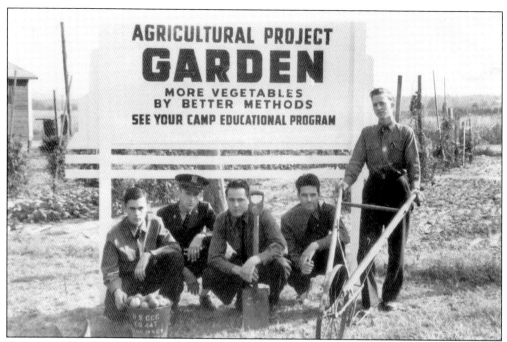
Company 447 at Chatsworth conducted forestry projects on private lands and built Fort Mountain State Park. In their spare time, the men conducted an agricultural project where each man developed his own individual garden plot. (Courtesy of National Archives.)

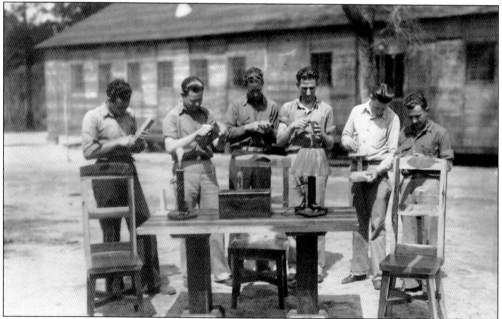
Company 446 at P-92 near Brunswick offered a class in woodworking. These enrollees were photographed carving cedar and with items they had made in the class. The company was organized on June 3, 1933, and received their conditioning training at Sullivans Island, South Carolina. Their first camp was at Toccoa Falls (P-74) before they were reassigned to Blythe Island at Brunswick. (Courtesy of National Archives.)

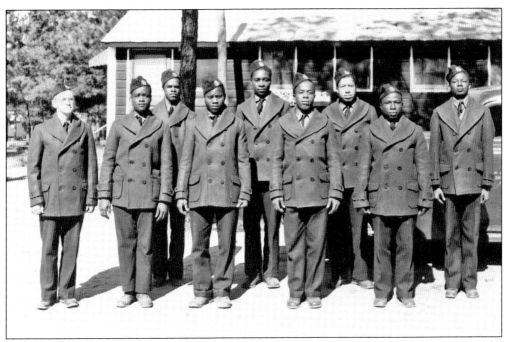

The instructor and members of the radio operators class of Company 4459, Americus, posed for this official photograph. The instructor noted later that several of the men now operated camp radio stations. (Courtesy of National Archives.)

The men of Company 4459 at Soil Conservation Service Camp 14 receive the safety award in this photograph. During the early years of the CCC, many local communities resisted and protested against having African American companies established in their locale. Yet other communities, with mostly white citizens, proudly proclaimed their pride in the work conducted by "colored" camps. (Courtesy of National Archives.)

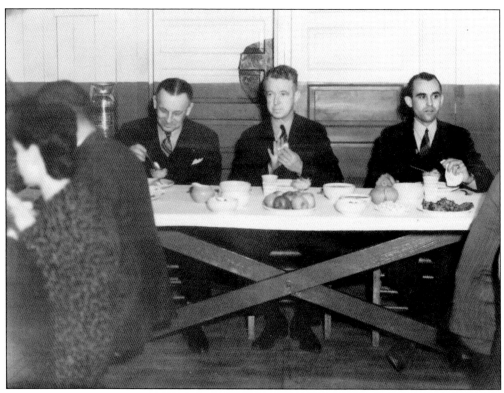

Director James McEntee (center at table) dined with Colonel Summers and Lieutenant Henderson on Thanksgiving at Camp NP-4 near Marietta. The men of this camp worked to develop the Kennesaw National Battlefield. (Courtesy of National Archives.)

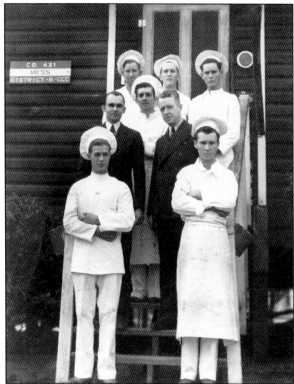

After dinner, McEntee posed with the company's cooks on the step of the company mess. Both Fechner, the CCC's first director, and McEntee were known for their hands-on leadership style. (Courtesy of National Archives.)

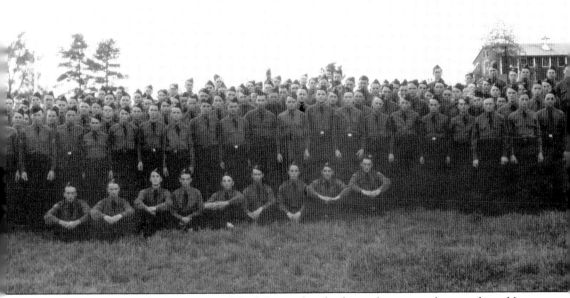
The entire company of Camp National Park-5 completed a first-aid training class conducted by local authorities and then posed for this group photograph. Company 1426 worked to develop Ocmulgee National Monument. (Courtesy of National Archives.)

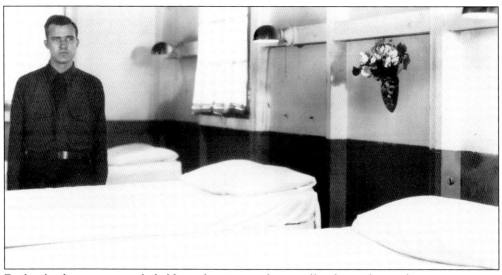
Evidently, the training included housekeeping as this enrollee first aid attendant poses next to the well-made beds of the camp hospital. (Courtesy of National Archives.)

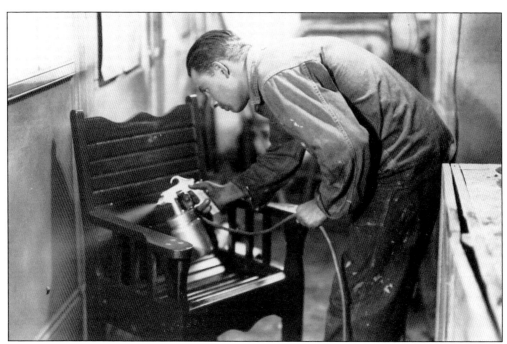
Other camp activities included furniture making. Here an enrollee spray paints a chair he made in woodworking class. (Courtesy of National Archives.)

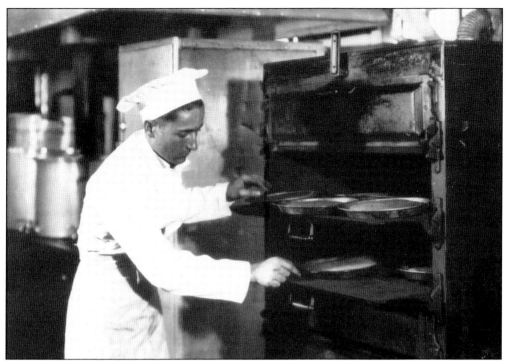

At almost every camp, enrollees could train as cooks. Here at Macon's Company 1426, a cook removes cornbread from the oven. This skill was one highly sought after as the armed forces began mobilizing in the early 1940s. (Courtesy of National Archives.)

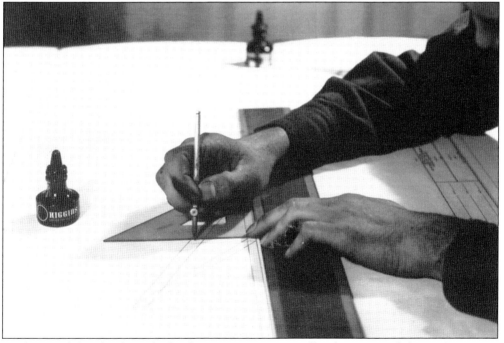

Working with local technical schools, some CCC camps offered a variety of classes. At Macon, men could learn mechanical drafting. (Courtesy of National Archives.)

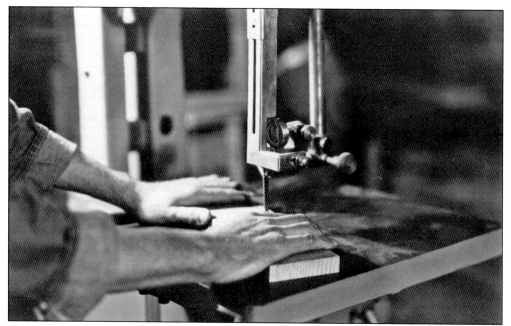
Company 1426 men could take classes in the evening at the Macon Vocational School and learn a trade. Here a CCC man is learning to use a band saw. (Courtesy of National Archives.)

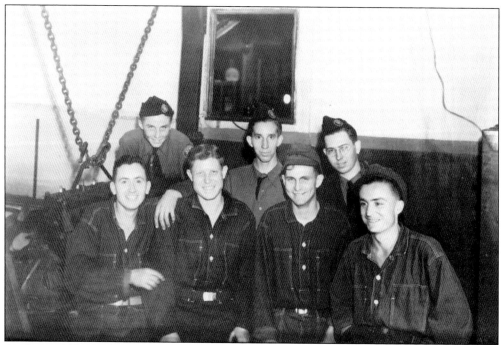
As the world learned the benefits of the automobile, mechanics were needed everywhere. The enrollees' auto mechanic class at Company 1426 practically guaranteed these men a job in the civilian world. (Courtesy of National Archives.)

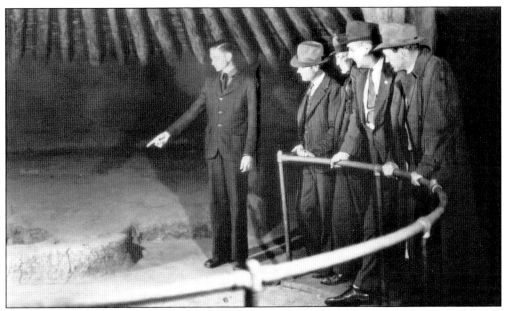

An enrollee guide was photographed giving a lectured tour inside the Indian Council Chamber at Ocmulgee National Monument at Macon. The CCC worked on archaeological and reconstruction projects at the park as well as forestry and construction of park buildings. (Courtesy of National Archives.)

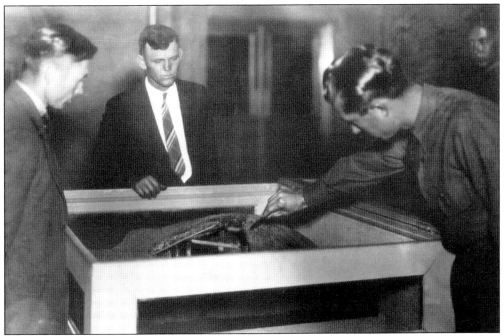

Here the enrollee guide showed his visitors a model of the Indian Council Chamber's construction. In addition to learning the history of the site, these young men were required to be well spoken and to dress in a suit and tie while giving tours. (Courtesy of National Archives.)

Like most camps, NP-5 trained their men in the use of equipment such as bulldozers. With the outbreak of World War II only a few years later, the army found that these men were invaluable in the building of airfields and other facilities as our armed forces moved into enemy territory. (Courtesy of National Archives.)

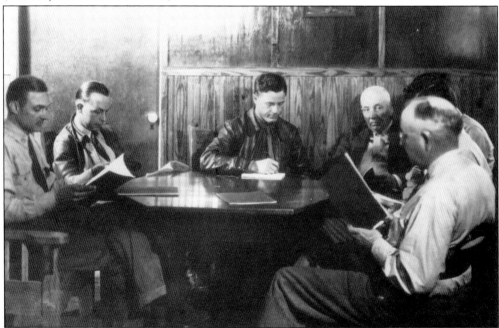

NP-5's supervisory personnel discussed future plans during this conference. It was the responsibility of these men to make sure the after-work activities and educational opportunities afforded the CCC enrollees would prepare them for civilian employment after their enlistment period ended. (Courtesy of National Archives.)

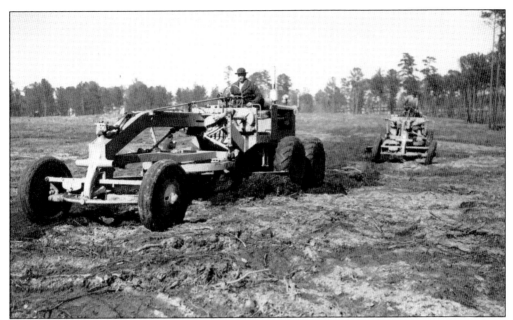

As the world fell into conflict in Europe, Asia, and North Africa, some American leaders realized that the United States would be eventually drawn into this conflict just as they had been with World War I—the "war to end all wars." CCC camps were created to begin preparing our nation to mobilize. Here CCC workers at Fort Benning clear large areas for maneuvers, training, new barracks, firing ranges, and other necessary facilities. (Courtesy of National Archives.)

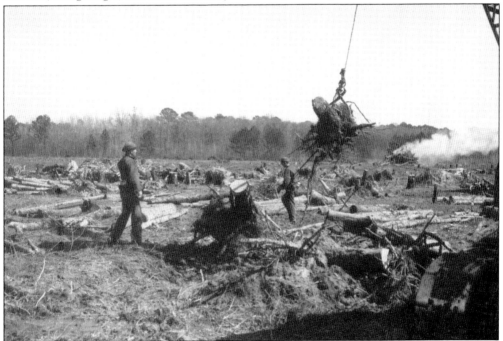

Although taken at Fort Benning, this photograph could have been easily repeated at Camp Stewart at Hinesville or Camp Wheeler at Macon. Across the nation, CCC camps worked on the development of military camps. (Courtesy of National Archives.)

In July 1940, over a year before the attack on Pearl Harbor, CCC director McEntee spoke to a group at the George Washington National Forest about the new mission of the CCC. He said, "Now a new objective has been added to the program of the Corps—the training of men for specialized work in connection with national defense. . . . We are equipped and have the man power to carry out a board program of intensive training in such fields as automotive and aviation mechanics, cooking and baking, road and bridge building and maintenance, map making and surveying, radio and telephone communications. . . . It is on this framework that we are building our national defense training program." As the work continued to clear timber for firing ranges at Fort Benning, the other skills these CCC men had learned came to be the most important as the United States approached World War II. (Courtesy of National Archives.)

Seven

AFTER THE WORK DAY ENDED

In *We Can Take It: A Short Story of the* C.C.C., first printed in 1935, Ray Hoyt entitled his seventh chapter " 'Life' Begins at 4:30 P.M." He dedicated the words and sketches in this chapter to the numerous activities provided by the CCC camps for the men after the work day was completed. Activities abounded, not only recreational but educational as well.

FDR first visited camps on August 15, 1933, and continued such visits or tours of inspection into the fall. Seeing the widespread success of the CCC, he immediately extended the corps at full strength for another six months and then announced the decision to permit reenrollment for a second six-month term. In November of that year, FDR announced a plan for a nationwide, Washington-directed CCC education service based on an ambitious plan submitted by W. Frank Person, the CCC director of selection.

Within each district was a director of education. Teachers were hired, education buildings constructed, materials supplied, and some men volunteered to attend classes in order to obtain a high school diploma. Some classes were taught by the camp's resident army officers, others by local teachers. By June 1937, some 35,000 illiterate CCC men had been taught to read and write, while more than 1,000 had obtained high school diplomas. Thirty-nine had graduated from college; at least 26 enrollees had received college scholarships. Classes varied greatly at each camp, but generally half were vocational and the remainder were educational. Classes were 16 percent elementary level, 27 percent high school, and 5 percent college.

Yet not all of the men's free time was taken up with classes. They organized sports teams and played against other CCC camps. Tournaments were held and trophies awarded. Friday and Saturday nights often found the men being trucked into "town" for a movie. Or even better, the local girls were brought by truck to the camp for a dance. Some communities held social evenings for the men of the local camp.

Generally, the CCC developed a well-rounded man who worked and played and learned with equal enthusiasm.

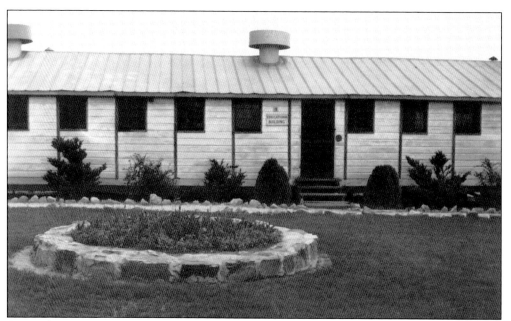
Across the nation at CCC camp after camp, the educational buildings looked very much alike. This one was at Camp Chipley. Many of the young CCC men had left school because of family finances or simple rebellion. In these buildings, many found the chance to gain their education in a way that would be neither embarrassing nor a mark of inferiority. Flexibility in instruction and lessons designed to meet their needs encouraged them to attend. (Courtesy of National Archives.)

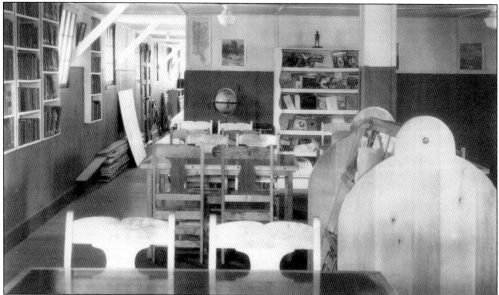
At each camp, a library provided the men with reading materials and a quiet place to write letters home and to study. The CCC organized groups of nine mobile libraries, which were rotated among nine camps. Each group contained, in this order: adventure and mystery (17), miscellaneous fiction (29), Westerns (12), travel (20), history and biography (12), science fiction (29), athletics (5), and religion (3), along with 45 periodicals and the Sears-Roebuck catalog. (Courtesy of National Archives.)

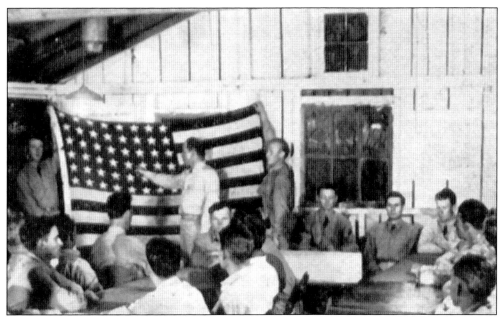

At Chatsworth, Company 483 valued its educational opportunities. This civics class is discussing the 48-star American flag. The men usually attended class in uniform during the evening hours. (Author's collection.)

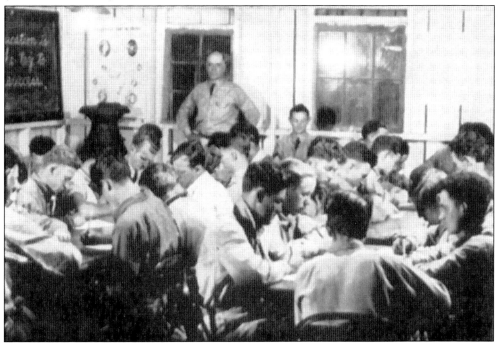

Combining the work day and education worked well for the CCC. An arithmetic lesson might focus on the diameter of a tree. Some men learned the engineering of a bridge or how to figure concrete needs for a work project or how many seedlings were needed per acre. Reserve army officers taught algebra, geometry, trigonometry, and calculus to men who wanted to learn. This class photograph was taken at Chatsworth, Company 483. (Author's collection.)

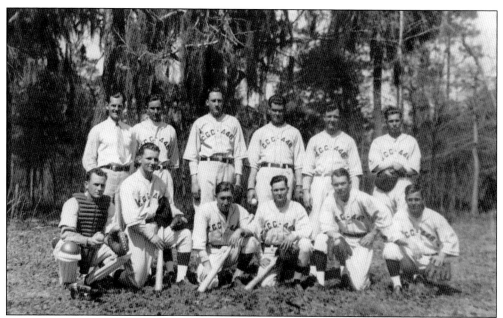

Company 446 of P-92, Brunswick, fielded a baseball team led by D. E. Zimmerman, camp educational advisor. Most camps had baseball teams, and tournaments were a popular weekend activity. At other times, the teams played the local men and boys. A few professional baseball scouts found that these teams were a good source of talent, and several young men found themselves playing in the big leagues after their enlistment was up. (Courtesy of National Archives.)

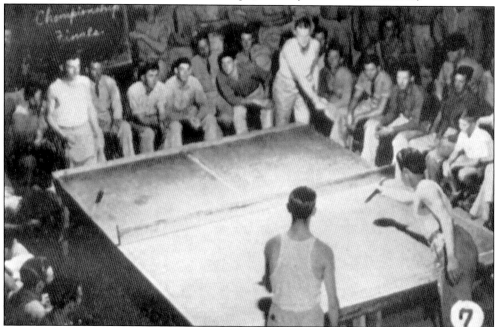

Ping Pong or table tennis was a popular sport in many camps. Equipment was cheap and easily obtained. At each camp, money earned by the canteen was used to enrich camp life, often with sports equipment, a piano or other musical instruments, or costumes for a dramatic production. (Author's collection.)

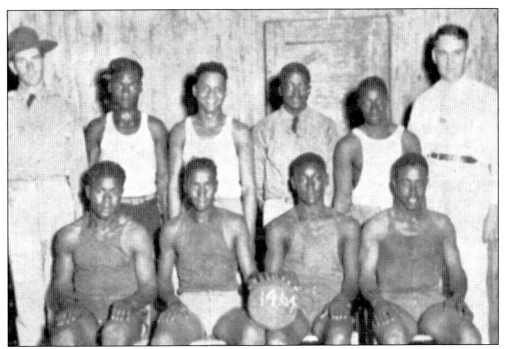

At Fort Oglethorpe, the men organized a basketball team and a tennis team and held boxing matches. Due to segregation and the sparsity of "colored" camps, these African American CCC men had to travel farther to find opposing teams. (Author's collection.)

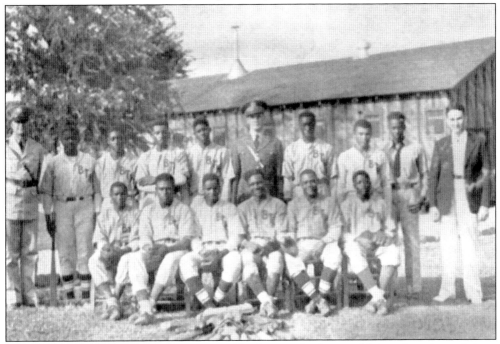

Fort Oglethorpe's baseball team was managed by the camp's advisors. African American advisors were extremely rare in CCC camps. Fechner argued against such hiring, and only upon direction of Secretary of the Interior Harold Ickes, in 1935, did he do so. (Author's collection.)

Hard Labor Creek was lucky to have enrollee T. Clark, a certified lifeguard. Clark was photographed giving a life-saving class to other CCC enrollees. During the first year of the CCC, the high number of accidents and deaths was a major concern. In the spring of 1934, a Safety Division was established. Accident prevention techniques were demonstrated and safety measures implemented. By 1936, accident and death rates were lower than for the general population. (Courtesy of National Archives.)

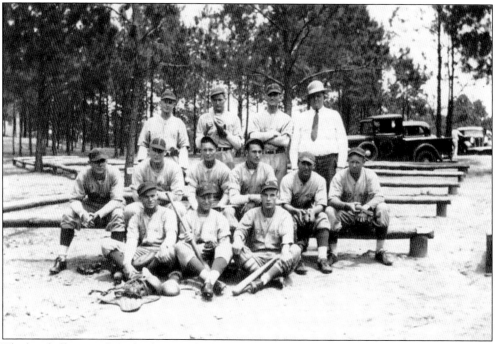

The baseball team of Hard Labor Creek played on a field with bleachers. These CCC-constructed seats consisted of shaped logs or thick planks placed atop short tree sections. (Courtesy of National Archives.)

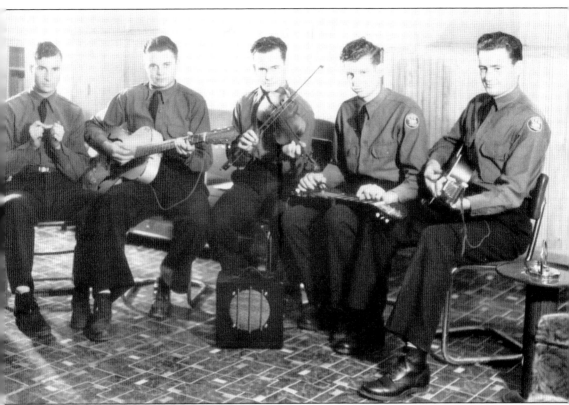

The project superintendent at Macon's NP-5 camp was proud of his company's string band, which presented a weekly program over the local radio station. *Happy Days*, the official CCC newspaper, often carried articles about camp bands and musical productions. (Courtesy of National Archives.)

Among the collection of CCC photographs and documents held by the National Archives at College Park, Maryland, are a remarkable group of sketches done by CCC enrollees. Like this one of the men in the barracks, they portray the CCC life in a way that could only be captured by one who lived it. This one appears to be signed "Raynaud '36." (Courtesy of National Archives.)

This sketch, entitled "Sunday Papers" by Thomas Rost Jr., presents another view of leisure time in the CCC. The men did not work on weekends unless inclement weather during the week had stopped work; then Saturday might be used to catch up on required work hours. Work on Sunday was nothing short of an emergency such as a forest fire. (Courtesy of National Archives.)

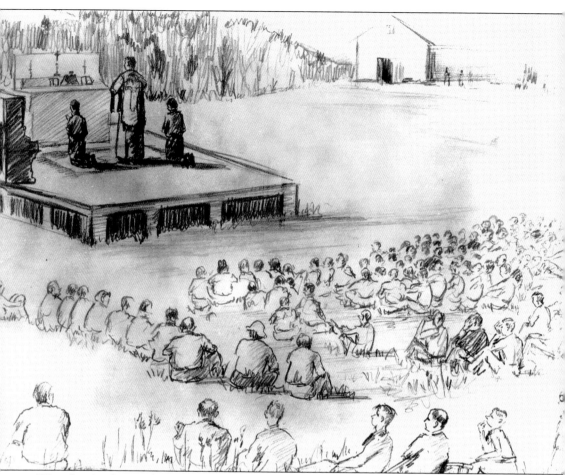

This sketch of a Sunday morning church service had no title or illustrator. Little information is given in histories of the CCC about church services for the men. It is known that, where possible, the men were trucked to the local community for Sunday services. This illustration suggests that in remote areas outdoor services were organized, weather permitting. (Courtesy of National Archives.)

Camps located where off-site education facilities could be utilized often allowed enrollees to take classes related to their natural talents. These talents were also encouraged during the work day, as men with artistic skill were used to create camp signs and illustrations for other work-related products. The CCC issued various manuals including one that taught sign lettering. The illustration above with its alphabetical labeling was most likely produced for a particular purpose, not just as a free-time sketch. The illustration below shows a page from the CCC's sign manual. (Above courtesy of National Archives; below courtesy of the Georgia Department of Natural Resources.)

Don't get the wrong idea about the CCC, that it was all work even after the official day was completed. While many of the men took advantage of educational opportunities or recreation, some just took advantage of the situation. It seems that at most camps one or two ambitious young men became entrepreneurs and increased their own personal wealth by doing the laundry of others for a small fee. Some even bought washing machines to make the work easier. At other camps, communal machines were purchased with "canteen" profits. (Courtesy of National Archives.)

Some CCC men entertained themselves with the antics of High Pockets and Half Pint from *Hysterical History: Civilian Conservation Corps*. This paperback combination of autograph book, photo album, and comic book was printed by the Peerless Engraving Company of Little Rock, Arkansas, and was sold to CCC members across the nation. (Author's collection.)

6/9/34

LIFE SAVERS.—First Lieut. M. Bush, who relieved Capt. R. B. Reynolds as C. O. of Co. 1429, Warm Springs, Ga., has started a life saving class. They are held three times a week at the famous Warm Springs Swimming Pool, and 40 members have enrolled. Many of them are counting on jobs the next summer as life guards, and they are showing rapid progress.

Co. 1429 — 6/9/34

Party Rivals Gayest Affairs of Idle Rich

Mrs. Gotrocks in her Long Island Estate couldnt have tossed a swankier, gayer affair than the recent birthday party thrown by Co. 1429, Warm Springs, Ga.

With a supper and a dance, and with about 200 guests present, it was a huge social success. The hall was decorated with colored lights, and an 11-piece orchestra was imported to provide the necessary rhythm. Many officers from Ft. Benning and other distinguished visitors were on hand.

8/18/34

Camp School Proud of Its Swell Faculty

The forestry department of Co. 1429, Warm Springs, Ga., is showing strong co-operation with the educational department. Adviser Nunn now numbers on his faculty Forester Hartman, who teaches English. He has 45 men in his class.

Typing is another forester-taught class, under Mr. Thomas. The group has just secured six new "mills" on which to practice. Forestry, of course, is taught by a member of that department. He is Dr. Conradi, who has had teaching experience in several of the larger colleges of the country. The class in forestry numbers 43.

An order has been placed for the machinery for the woodworking plant. The building to house this equipment has already been completed. Many useful articles of furniture are planned by the class for use in camp. Camp Supt. Darnell will teach this course.

9/15/34

Work on Pine Mountain Park Will Start Soon

Not far from Warm Springs, Ga., the vacation place of President Roosevelt and the home of Co. 1429, the development of Pine Mountani State Park is being contemplated.

Approximately 1,500 acres of land have been purchased. The work will consist of a series of clearance and construction jobs. An artificial lake will be built covering an area of 30 acres entirely surrounded by pine forests.

Along the lake shore modern rustic log cabins of two and three rooms will be set. These cabins are for the convenience of campers, tourists, nature lovers and fishermen. A dam which will have an overall of 620 feet is also on the list of proposed projects.

9/3/34

MAGICIAN MYSTIFIES WARM SPRINGS CAMP

It seems that magic is afoot at Co. 1429, Warm Springs, Ga. G. W. Weaver, is the "mystic" who is fooling the audiences. Recently, he put on a show to a large crowd. According to reports, the presentation was a good one.

4/28/34

"The Meriwether Tri-C News," of Co. 1429, Georgia, in the Fourth;

10/13/34

Press Time Chatter

The Meriwether Tri-C News, that four page, printed newssheet of Co. 1429, Warm Springs, Ga., celebrates the completion of its first year of publication. Its record of 12 months publication, except for one time when the press broke down, with each issue in true newspaper style, is one "for the book." The paper was founded by Robert R. Gibson, a newspaper man, who undertook the publication as a civic enterprise. He found it impossible to continue, at which time and ever since, the company carried on with the able assistance of Louis Weinburg, Editor of the Warm Springs Mirror. The Tri-C News has hit a high point in C.C.C. accomplishments. A big orchid to W. I. Nunn, Editor-in-Chief, and his staff.

9/8/34

Enrollee Badly Injured; Breaks Leg in Tree Fall

While climbing a tree, Frank Ponder, sub-leader of Co. 1429, Warm Springs, Ga., was severely injured. He was about 50 feet up when without warning the partially cut tree gave way.

An ambulance was called from Fort Benning and Ponder was rushed to a doctor. After the examination it was discovered that he had a broken leg just below the hip joint. The camp commander and the project superintendent drove to the doctor's office to make certain all was being done for him.

8/11/34

The entire outfit of Co. 1429, Warm Springs, Ga., was informed that unidentified culprits had left watermelon rinds on the camp grounds near the tennis courts.

With due formality, the company marched in solemn formation to the spot. There, after hearing a funeral dirge sung, Jack Harp preached the burial service.

A prayer was sent up that no more villians would willfully mar the grounds, and the rinds were interred. Flowers for the occasion were gathered by William Weaver, the camp's noted magician who has performed on America's largest stages. It is not reported that he pulled them out of his hat, however.

10/13/34

1st Lieut. Newman R. Burns has replaced Lieut. Sutherland of Co. 1429, War Springs, Ga.

9/8/34

Large Fireplace Being Built of Native Stone

A huge fireplace that will be eight feet wide, is being built by Co. 1429, Warm Springs, Ga. It is being made of native stone and will hold large logs of oak. The work is being done with the aid of one experienced mason.

8/25/34

Even tho the team of Co. 1429, Warm Springs, Ga., lost all but two of the ball team which had won 20 out of 25 games played, they are still going strong. Five games have been played since the reorganization, and all five were won. Fred Glover, star hurler, pitched a no-hit, no-run game against Raleight recently. He has pitched four

Once a week, the men could read about CCC happenings across the nation in the corps' official newspaper, *Happy Days*. It was published every Saturday for nine years and told stories from camps across the nation. The camp commander at Warm Springs saved any *Happy Days* reference to his camp and submitted a copy along with his official report in 1934. (Courtesy of National Archives.)

Eight

GEORGIA'S CCC LEGACY

Throughout the years of the CCC, the organization fought for permanence. Despite its initial successes, every year saw attempts to reduce the number of enrollees or to dissolve the corps completely. From 1933 to 1937, the number of enrollees waxed and waned based on economic, social, and political forces. Yet high unemployment rates across the nation led many to reenlist as often as allowed and brought new men to the corps every year.

As war approached, the CCC weakened. New jobs opened in defense plants, and enrollee numbers dropped. Some, especially the U.S. Army, argued the young men should receive formal military training. While this was initially rejected by CCC leadership, September 1940 saw CCC men being given 20 hours per week of basic defense training. Those who excelled in needed fields, including cooking, first aid, demolition, road and bridge construction, radio operation, and signal communications, were moved to full-time defense training and work.

In the final two years of the CCC, 1940–1942, conservation work continued. CCC men planted forests, developed parks, and cut trails. In Georgia, new camps opened at Fort Benning and Camp Stewart. Forest camps closed. State park work was completed or transferred to the state for completion. The CCC era was ending.

Despite its limitations and its lack of permanence, President Roosevelt's Civilian Conservation Corps was a glorious experiment. Its effect on the nation's attitude, outlook, natural resources, and spirit cannot be overstated. Speak with a former CCC man, or listen to one of the many oral interviews, or read one of these men's memoirs, and, although you will hear about the bad times, the hard work, and the homesickness, you will not mistake that these men are proud of what they did and who they became.

Their motto was "We Can Take It." Their nickname was "Roosevelt's Tree Army." Their legacy was 10 Georgia state parks, 3 beautiful national forests with miles of trails, 2 national battlefields (Kennesaw and Chickamauga-Chattanooga National Military Park), Ocmulgee National Monument, Fort Pulaski National Monument, and parts of the Okefenokee Wildlife Refuge.

They arrived at camp as boys, young men not yet understanding their role in society. They were scared and covered it with brashness. The rookies or softies braved the hazing by the ones that came into the corps before them. They were homesick. After a day's work, they were tired and sore. Desertion was a problem in the corps; at times, the rate rose to 18 percent. Yet those who remained said, "Thanks for the job, Mr. President." This sketch is by S. Wheeler. (Courtesy of National Archives.)

CCC camps with entrances similar to this one (located at P-70 Brantley-Nahunta) existed in all 48 United States. The CCC employed 5 percent of the total U.S. male population throughout its existence. Within three months of its establishment, 250,000 young men were working in our nation's forests. This was the greatest peacetime mobilization of American youth ever seen. (Courtesy of National Archives, H. M. Sebring photograph.)

Total national enrollment was 3,465,766 (some men enrolled more than once). Of these, more than 78,600 men enrolled in Georgia. The state had an average of 35 active camps per year with a total financial obligation of more than $69.5 million. These young men were photographed at Fort McPherson in Atlanta. (Courtesy of National Archives.)

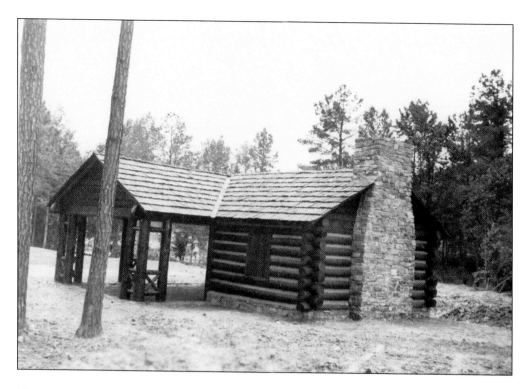

Next time you visit a Georgia State Park, look closely at that picnic shelter or bathhouse, or lodge, or bridge. Was it built by the CCC? Can you see those boys, joking, complaining, and laboring under a hot sun or in freezing weather? Stay in one of the small cottages in many of Georgia's parks and check out the workmanship. Above is Franklin D. Roosevelt State Park's CCC-built picnic shelter. Below is a CCC-built cabin at Vogel State Park. (Both courtesy of National Archives.)

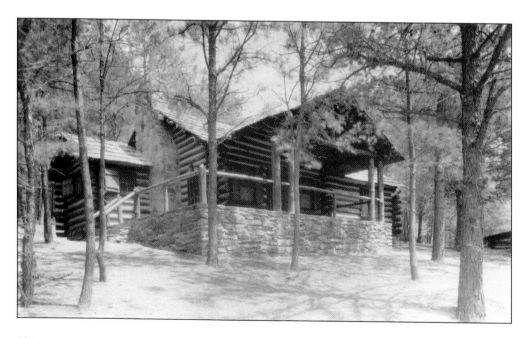

This image is from *Hysterical History: Civilian Conservation Corps.* (Author's collection.)

LIST OF CCC CAMPS

The official records of camps in each state are now difficult to read as a result of poor paper quality and size of type. Also camps moved and companies moved. The following is a list of camps on private lands compiled from these records; however, this list is not accurate for all time periods. "P" is private land, managed by U.S. Forest Service. "SCS" is Soil Conservation Service Camp.

CAMP	CCC COMPANY	POST OFFICE	CAMP	CCC COMPANY	POST OFFICE
P-52	1413	Homerville	P-85	Unknown	Nashville
P-53	1412	Hinesville	P-86	Unknown	Lookout
P-54	1411	Albany	P-87/F-17	Unknown	Armucheo
P-55	431	Blairsville	P-89	Unknown	Swainsboro
P-56	1429	Warm Springs	P-90	4458	Lakeland
P-57	1424	Waynesboro	P-92	446	Brunswick
P-58	488	Ellijay	P-93	4458	Waleska
P-59	1448	Fargo	P-94	1424	Waynesboro
P-60	452	Woodbine	P-95	5430	Fendig
P-61	1414	Soperton	P-96	415	Lanier
P-62	1424	Baxley	P-97	Unknown	Haylow
P-64	478	Crawfordville	SCS-1	485	Athens
P-65	2418	Jessup	SCS-2	Unknown	Cassville
P-66	1426	Brooklet	SCS-4	3437	Villa Rica
P-67	470	Brinson RFD	SCS-5	3438	Washington
P-68	408/1447	Douglas	SCS-6	3439	Sparta
P-69	464	Commerce	SCS-7	3440	Stevens Pottery
P-70	1436	Nahunta	SCS-8	Unknown	Musella
P-71	1480	St. George	SCS-9	4459	Buena Vista
P-72	1434	Waycross Route 5	SCS-10	4460	Lumpkin
P-73/F-15	427	Hiawassee	SCS-11	5433	Buford
P-74	446	Toccoa Falls	SCS-12	4485	Monticello
P-75	476	Fort Gaines	SCS-13	485	Cartersville
P-76	472	Chula	SCS-14	4459	Americus
P-77	1449	Tate	SCS-15	4485	Greensboro
P-78	1449	Butler	SCS-16	5433	Gainesville
P-79	460	Cornelia	SCS-17	3438	Royston
P-80	Unknown	Cloudland	SCS-18	3439	Soperton
P-81	1426	Bloomingdale	SCS-19	3482	Perry
P-82	1256	Reidville	SCS-20	3440	Tennille
P-84	Unknown	Folkston			

BIBLIOGRAPHY

Cohen, Stan. *The Tree Army: A Pictorial History of the Civilian Conservation Corps, 1933–1942.* Missoula, MT: Pictorial Histories Publishing Company, 1980.

Dearborn, Ned H. *Once in a Lifetime: A Guide to the CCC Camp.* New York: Charles E. Merrill Company, 1936.

Hoyt, Ray. *"Your CCC": A Handbook for Enrollees.* 2nd ed. Washington, D.C.: Happy Days Publishing Company, Inc.

———. *"We Can Take It": A Short Story of the C.C.C.* New York: American Book Company, 1935.

"New Deal for Parks: Civilian Conservation Corps Celebrates Its 75th Anniversary." *Uncommon Ground* 13, no. 2 (Summer 2008).

Paige, John C. *The Civilian Conservation Corps and the National Park Service, 1933–1942: An Administrative History.* Washington, D.C.: National Park Service, Department of the Interior, 1985.

Salmond, John A. *The Civilian Conservation Corps, 1933–1942.* Durham, NC: Duke University Press, 1967.

"The Civilian Conservation Corps. Volume 1." *Foxfire* 16, no. 4 (Winter 1982).

"The Civilian Conservation Corps. Volume 2." *Foxfire* 17, no. 1 (Spring 1983).

Townsend, Billy. *History of the Georgia State Parks and Historic Sites Division.* Online manuscript, revised October 29, 2001. gastateparks.org/content/georgia/parks/75th_Anniv/parks_history.pdf.

This is the emblem of the Civilian Conservation Corps.

Discover Thousands of Local History Books Featuring Millions of Vintage Images

Arcadia Publishing, the leading local history publisher in the United States, is committed to making history accessible and meaningful through publishing books that celebrate and preserve the heritage of America's people and places.

Find more books like this at
www.arcadiapublishing.com

Search for your hometown history, your old stomping grounds, and even your favorite sports team.

Consistent with our mission to preserve history on a local level, this book was printed in South Carolina on American-made paper and manufactured entirely in the United States. Products carrying the accredited Forest Stewardship Council (FSC) label are printed on 100 percent FSC-certified paper.